Kawaii Doodle World

SKETCHING SUPER-CUTE DOODLE SCENES
WITH CUDDLY CHARACTERS, FUN DECORATIONS, WHIMSICAL PATTERNS, AND MORE

Zainab Khan Creator of
Pic Candle

ROCK
POINT

Brimming with creative inspiration, how-to projects, and useful information to enrich your everyday life, Quarto Knows is a favorite destination for those pursuing their interests and passions. Visit our site and dig deeper with our books into your area of interest: Quarto Creates, Quarto Cooks, Quarto Homes, Quarto Lives, Quarto Drives, Quarto Explores, Quarto Gifts, or Quarto Kids.

10 9 8 7 6 5 4 3 2 1

ISBN: 978-1-63106-697-9

Library of Congress Control Number: 2020936562

Publisher: Rage Kindelsperger
Creative Director: Laura Drew
Managing Editor: Cara Donaldson
Senior Editor: Erin Canning
Art Director: Cindy Samargia Laun
Interior Design: Merideth Harte

Printed in China

Contents

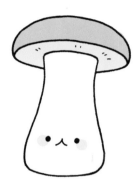

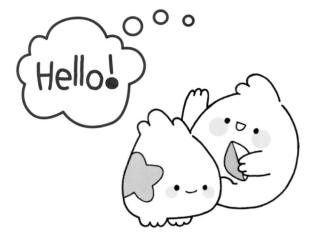

Hello!

My name is Zainab, but you can find my kawaii doodles on the internet under the handle Pic Candle.

I approach my doodles randomly without planning or thinking about the end results. I find this process to be very exciting because you never know what's going to happen. It's a surprise! I usually start with a doodle character or object that comes to mind and then keep drawing more characters and decorations, one by one, to fill up the page. While doodling, I focus only on the character or object that I'm drawing, not the big picture.

Regarding coming up with characters, they're mainly inspired by real-life objects and simple shapes (such as a sphere, cube, cylinder, pyramid, and cone) that I have modified or combined. I also like creating make-believe characters.

I hope this book inspires you to develop a love for doodling and creating kawaii characters and doodle scenes.

What Is Kawaii?

You might have heard the word. You have probably seen the hashtag. You definitely know the style. But what, exactly, does *kawaii* mean?

Kawaii is a Japanese concept or idea, dating back to the 1970s, that translates closely to "cuteness" in English. In Japan, the usage of the word is quite broad and can be used to describe *anything* cute, from clothing and accessories to handwriting and art. So if you are a fan of emoji art or the style of beloved characters like Hello Kitty, Pokémon, or Pusheen the Cat, then you already know and love the kawaii style of art!

While there are many interpretations as to what constitutes the "kawaii" art aesthetic, most people can agree that kawaii art is usually composed of very simple black outlines, pastel colors, and characters or objects with a rounded, youthful appearance. Facial expressions in kawaii art are minimal and characters are frequently drawn with oversized heads and smaller bodies.

In this book, I'll show you how to draw kawaii-inspired art using the things we see every day, like food, nature, office supplies, and more. The great thing about kawaii culture is that it's not limited to anything, so once you start practicing, you can turn even the most common thing into something kawaii!

How to Use This Book

Kawaii Doodle World includes five parts with over twenty doodle scenes for you to learn how to draw.

The doodles in Parts 1 to 3 are illustrated with simple step-by-step instructions, showing both Basic and Practice Steps, to get you started doodling. Part 4 includes more doodle scenes illustrating Basic Steps, and Part 5 shows you how to create doodle scenes within different shapes.

Each part also includes Get Inspired! pages with even more doodles to delight you. You can also use these pages for coloring.

At the end of the book is a section called Fun Time! with Search-&-Find Puzzles that you can also color.

Tools

You don't need to invest in many tools to get started doodling kawaii. You can use pen and paper, or you can draw digitally, or you can start with pen and paper and then scan your art in case you want to color it digitally. It's up to you!

BLACK PENS

The pens I use most are fineliner pens, as they come in various tip sizes. I prefer to work with three tip sizes for varying line widths, though your end results can also be achieved using only one pen. Here are the tip sizes I use:

- thin tip (for tiny details, patterns, and shadows)

- medium tip (for main outlining)

- thick tip (for thicker outlining outside of the main outlines—this is to make characters stand out and also for filling in large areas with black)

WHITE PENS

I use these for corrections and adding highlights.

PAPER

I'm not too picky when it comes to the paper I use for doodling. Basic sketchbooks and printer paper work just fine, but if you want to use something more professional, that's a personal preference.

MECHANICAL PENCILS

Since ink is permanent, sketching with pencil before inking is helpful when drawing complex characters. Mechanical pencils are great for drawing lines and the option of varying lead thicknesses is useful.

ERASER

A good eraser is always needed for fixing those sketching mistakes. And there are always mistakes!

RULER

Depending on how precise you want to be with your lines and such, it can't hurt to have a ruler on hand.

MARKERS AND/OR WATERCOLORS (optional)

I like using one or two colors and adding them only in some areas of my doodles, leaving other areas blank. This "semi-coloring" method works for me because it takes less time to do, and it's also easy and fun. The chances of ruining my doodles are also reduced with semi-coloring. If you want to color your doodles, semi-coloring is a good practice and less intimidating for beginners.

PHOTOSHOP (optional)

When I doodle using pen and ink and then scan the image, I use Photoshop to clean it and prepare a print-ready file. Sometimes, I also like to add colors to hand-drawn doodles digitally with Photoshop. Mixing the traditional and digital processes to create final artwork is also fun!

Tips & Tricks

CHARACTERS

Here are a few tips and tricks I have learned over time for creating kawaii characters.

- Sketch your characters with a mechanical pencil before inking them, especially more complex characters.

- When drawing square, rectangular, and pointy shapes, rounding corners and points always adds a cuter element to the character.

- Adding a simple face is always recommended, but if you don't have room, no worries. Faceless characters can also be cute!

- But if you prefer giving your characters a face, drawing their bodies or faces wider will give you more room to do this.

- Speaking of faces, go ahead and play around with the position of the face. You don't have to place the face in the center every time, or ever!

- Varying the distance between a character's eyes and mouth can really change the appearance of a facial expression.

- Drawing a nose, along with eyes and a mouth, can really add "character" to your characters.

- Most importantly, there are no right or wrong ways to doodle kawaii characters. Just experiment and try to come up with your own unique style with the help of this book!

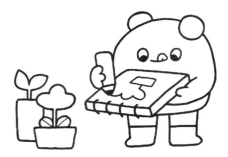

DETAILS & PATTERNS

To add to the cuteness factor of your characters and to give them some depth and texture, enhance them with details—dots, circles, diamonds, hearts, dashes, stars, stripes, action lines, shine, etc.—and patterns. Draw these in with a thin-tip pen after you have completed drawing and out-lining your character.

CREATING DOODLE SCENES

One of the goals of this book is to teach you how to draw your own doodle scenes, filled with lots of characters, decorations, and patterns. Once you practice drawing the doodles in this book, use these loose guide-lines to help create your own unique doodles.

- I usually divide my doodles into three parts: characters, decorations, and patterns.

- Create characters and decorations from the things around you—everyday objects, your favorite items, from your imagination, anything you want. Whenever you come across something that catches your eye, draw it in your sketchbook. Later on, you can turn it into your own character or decoration. You can also consult the Doodle Directory on the opposite page for ideas for decorations.

- The doodles in this book are approximately 4 x 6 inches (10 x 15 cm) and 6 x 8 inches (15 x 20 cm) in size. You can also fill entire pages of your sketchbook with doodle scenes, like those found in the Fun Time! section (page 131).

- The corners and center are the most common starting points for doodles. This book includes examples for all of these, but do not limit yourself to only these. Do what feels most natural for you. When drawing your doodles, you want them to have a sense of balance. This may take some practice, but you will get the hang of it!

- I always outline the characters and details in my doodles with a medium-tip pen. I then use thick outlining to emphasize whatever I want to stand out. I also like to sometimes add larger areas of black to my doodles, but you can skip this step. A thick-tip pen works best for these steps.

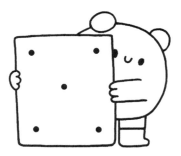

Doodle Directory

Here are some additional fun decorations and whimsical patterns to incorporate into your own doodles!

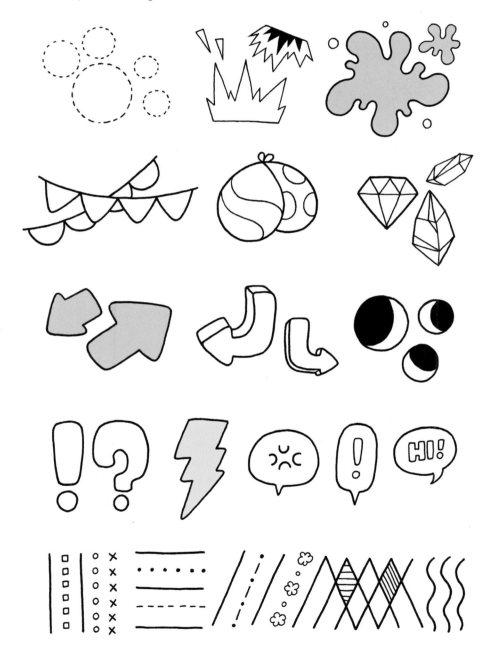

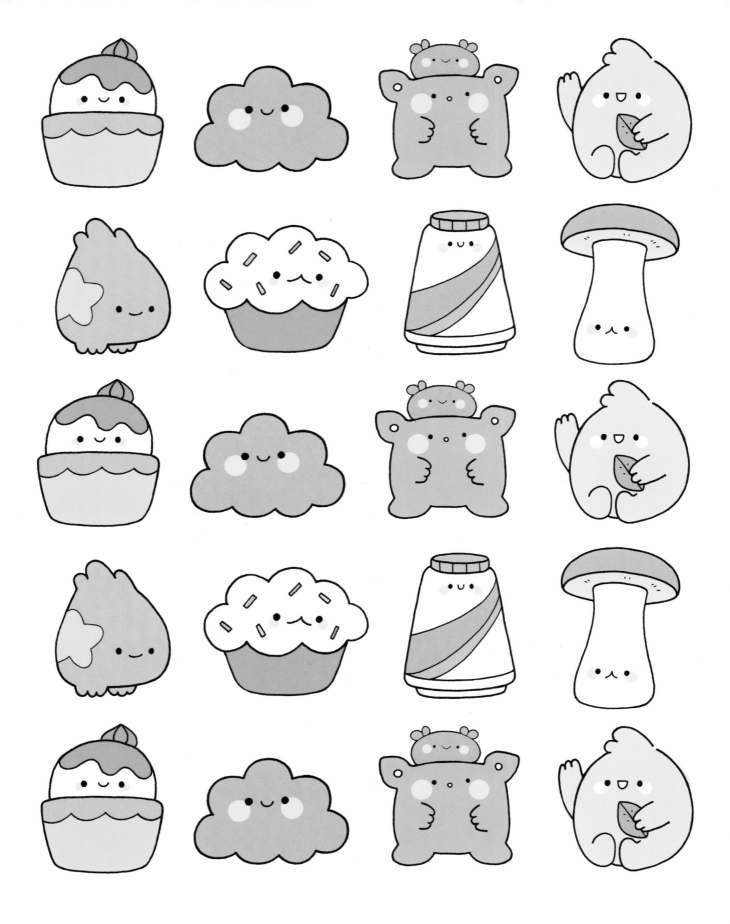

Part 1

Grouping
Kawaii
Characters

Clouds

Character (Learn how to draw a cloud below!)

How to Draw a Cloud

 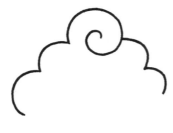 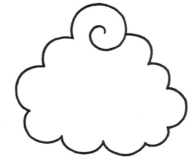 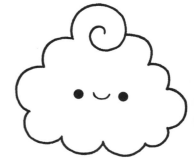

1. Draw a spiral or curlicue.

2. Draw scallops off the sides of the spiral.

3. Continue drawing scallops of varying sizes to complete the cloud shape.

4. Draw a cute face, of course!

BASIC STEPS

C'mon, give it a try!

1. Sketching

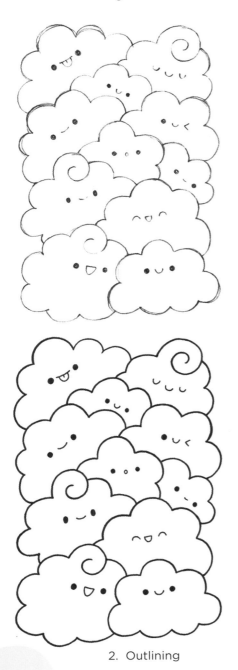

2. Outlining

3. Adding Details

PRACTICE STEPS

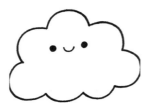

1. For this scene, we're going to start at the bottom and work up. Draw the cloud character on the bottom-right side of the scene.

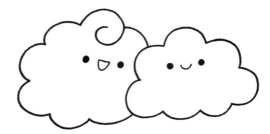

2. Add a second cloud to the left and slightly "behind" the first one. Give this cloud a nice swoop on top! As you draw your clouds to build your scene, remember to give them cute faces.

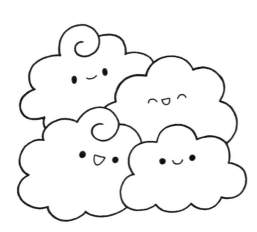

3. Moving up, draw two more clouds in the same styles as the first two.

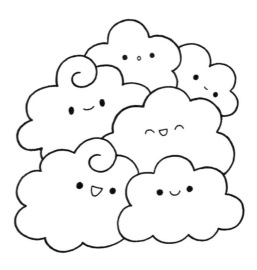

4. Continue building details your scene with a couple smaller clouds.

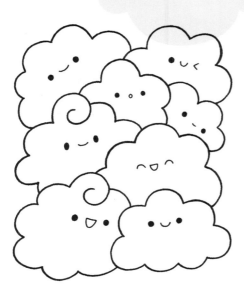

5. To keep the scene balanced and rectangular in shape, draw the next two clouds so that they fill out the space.

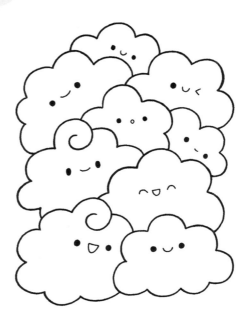

6. Draw a cloud peeking out between the two clouds you just drew.

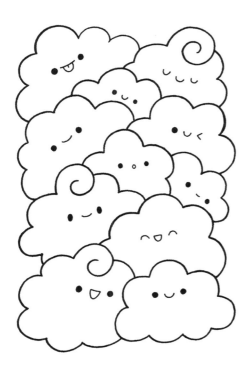

7. Round out the top of your scene with the final two clouds.

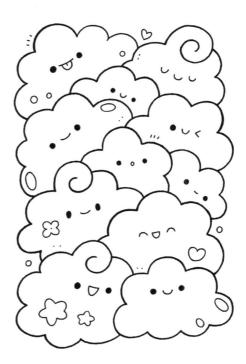

8. Finally, add some fun details.

Cupcakes

Characters (Check out the cupcake doodle tutorial on page 120!)

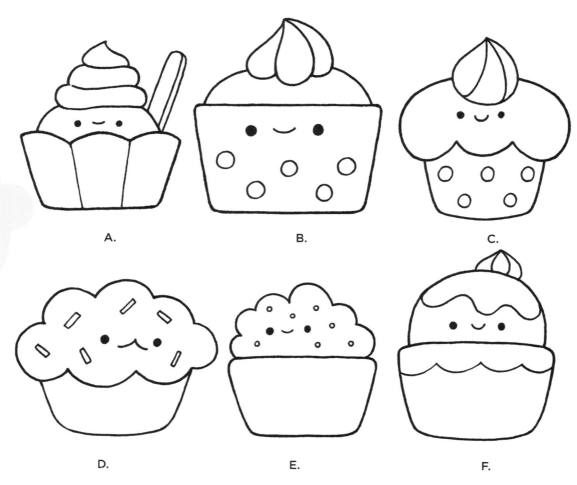

A.

B.

C.

D.

E.

F.

BASIC STEPS

1. Sketching

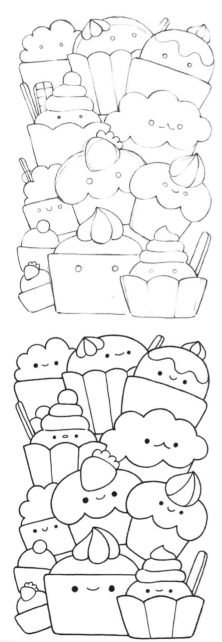

2. Outlining

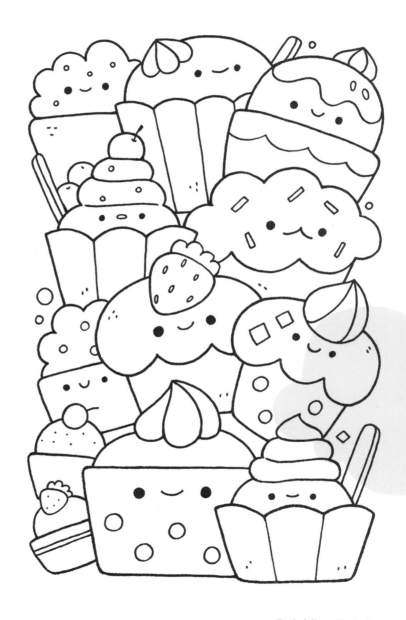

3. Adding Details

PRACTICE STEPS

1. For this scene, we're going to start at the bottom and work up. Draw character A on the bottom-right side of the scene.

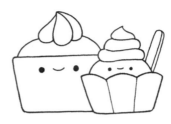

2. Add character B to the left and slightly "behind" the first cupcake.

3. Add a couple small cupcakes of your own design to the left of the one you just drew, with one on top of the other.

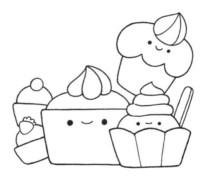

4. Moving up, draw character C above the first cupcake at a jaunty angle.

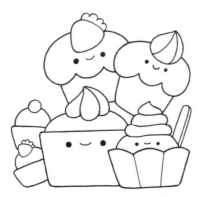

5. Draw another cupcake of your own design. This one can be a little larger. I topped mine with a strawberry!

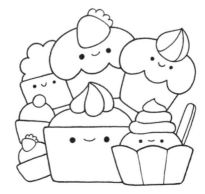

6. Add another original cupcake design to the left of the one you just drew that nicely fills the space.

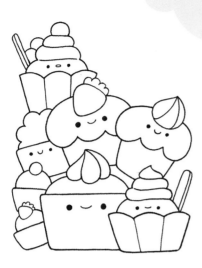

7. Moving up again, draw another cupcake of your own design on the left side of the scene. My cupcake is similar to the first cupcake character with lots of swirly frosting.

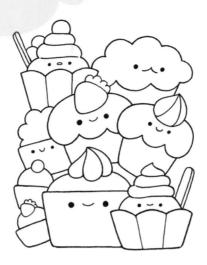

8. Add character D to the right of the one you just drew.

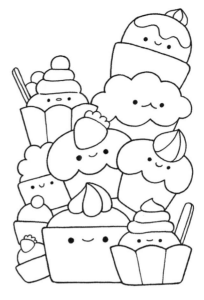

9. Continue building the scene by adding character F.

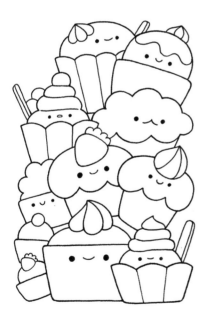

10. Fill in the space to the left of the cupcake you just drew with another original cupcake design.

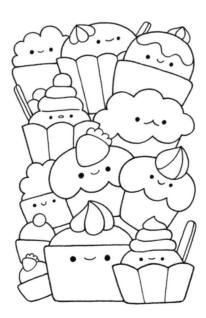

11. Round out the scene by adding character E in the top-left corner.

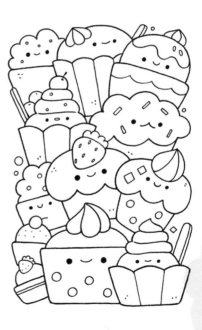

12. Finally, draw in the characters' finer details and add any additional fun details.

Mushrooms

Characters (Check out the mushroom doodle tutorial on page 119!)

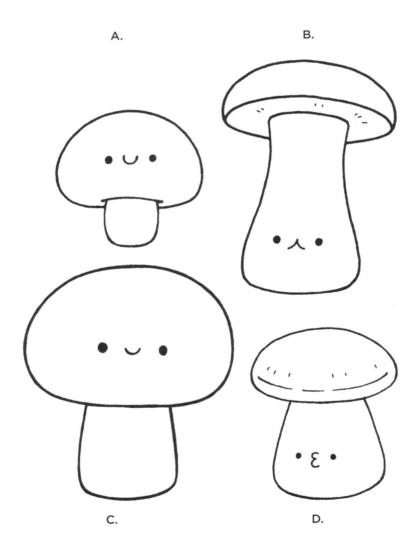

A.

B.

C.

D.

BASIC STEPS

You're getting the hang of it!

1. Sketching

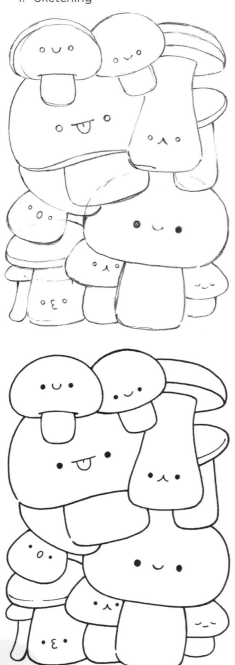

2. Outlining

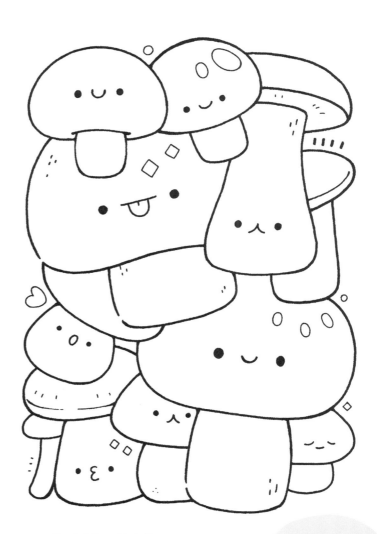

3. Adding Details

PRACTICE STEPS

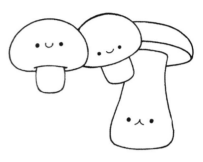

1. For this scene, we're going to start at the top and work down. Draw character A in the top-left corner of the scene.

2. Add the same character to the right of the first one, with its cap slightly "behind" the original mushroom.

3. Draw character B to the right of the first two mushrooms.

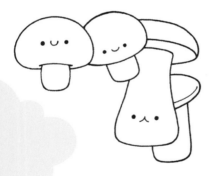

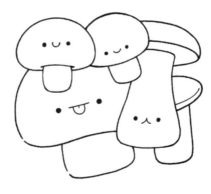

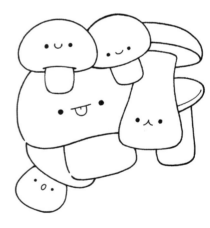

4. Draw a mushroom of your own design "behind" the stem of the mushroom from step 3, to fill the space below its cap.

5. Now, fill in the space to the left of the mushroom from step 3 with character C.

6. Draw character D off the left side of the large mushroom you just drew.

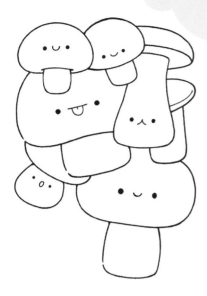

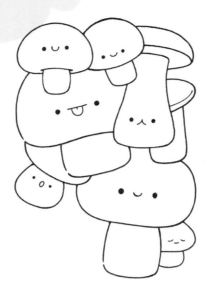

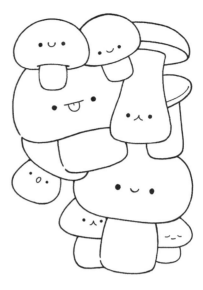

7. Moving down, draw another character C on the right side. This mushroom is establishing the baseline of your scene.

8. Fill in the space below the right side of the cap of the mushroom you just drew with a smaller mushroom of your design. This mushroom looks to be shy.

9. Add another original mushroom to fill the space below the left side of the cap of the same mushroom.

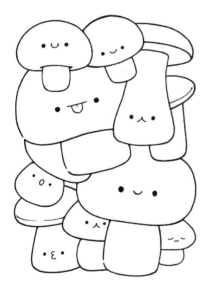

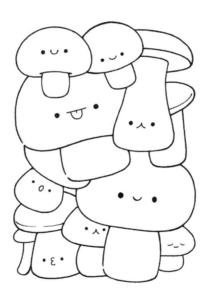

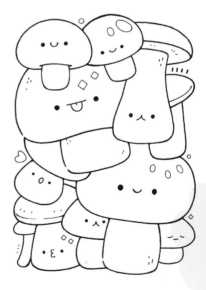

10. Fill in the space to the left of the mushroom you just drew with another character D.

11. Round out the bottom-left corner of the scene with a slender mushroom of your own design.

12. Finally, draw in the characters' finer details and add any additional fun details.

Doodle Monsters

Characters (Check out the doodle monster tutorials on pages 122 and 123!)

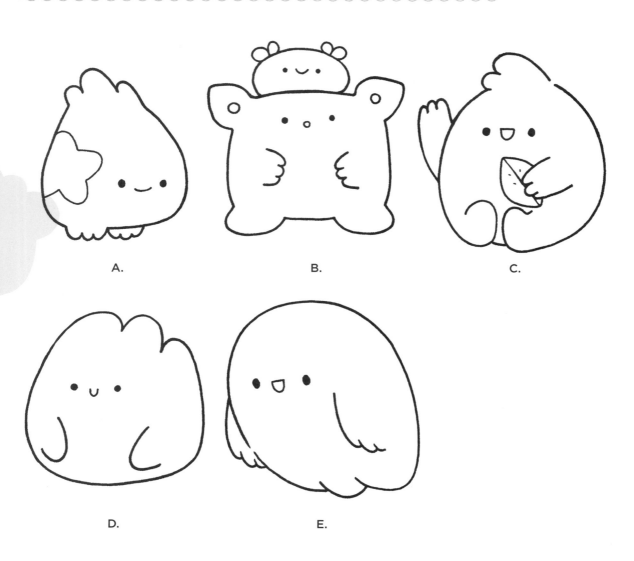

A.

B.

C.

D.

E.

BASIC STEPS

Doodling is fun, right?!

1. Sketching

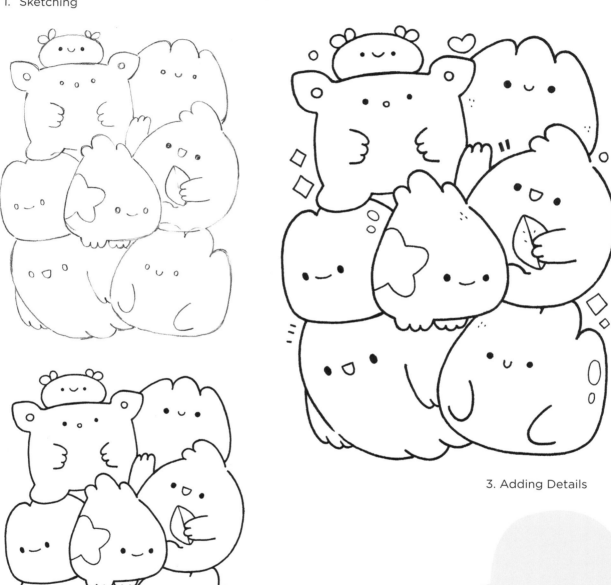

3. Adding Details

2. Outlining

Grouping Kawaii Characters 25

PRACTICE STEPS

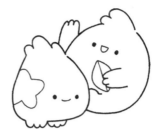

1. For this scene, we're going to start in the middle and build the scene up and then down. Draw character A smack-dab in the middle of your scene.

2. Add character C to the right and "behind" the first one.

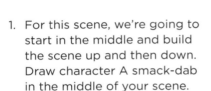

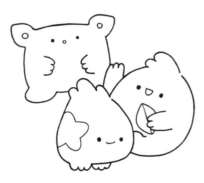

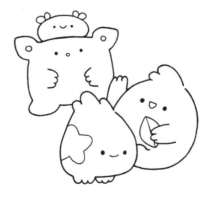

3. Moving up, place character B directly above the first one.

4. Add the little friend that sits on this character's head.

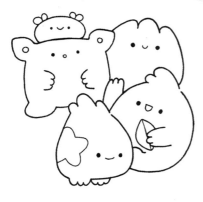

5. Fill the space in the top-right corner with character D.

6. Place another character D (smaller and without arms) to the left of character A.

7. Draw character D again and place it in the bottom-right corner.

8. Round out your scene by adding character E to the bottom-left corner.

9. Finally, draw in the characters' finer details and add any additional fun details.

GET INSPIRED!

Here are some more kawaii characters to doodle into a fun scene. Take what you learned and practiced in this section and give this doodle scene a whirl.

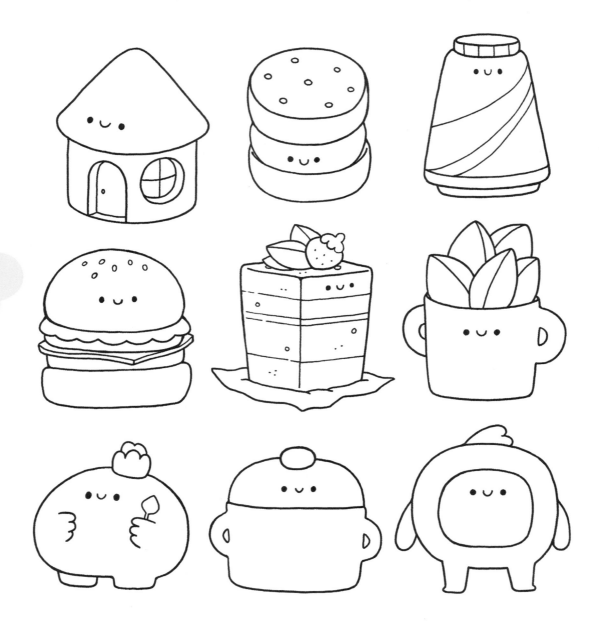

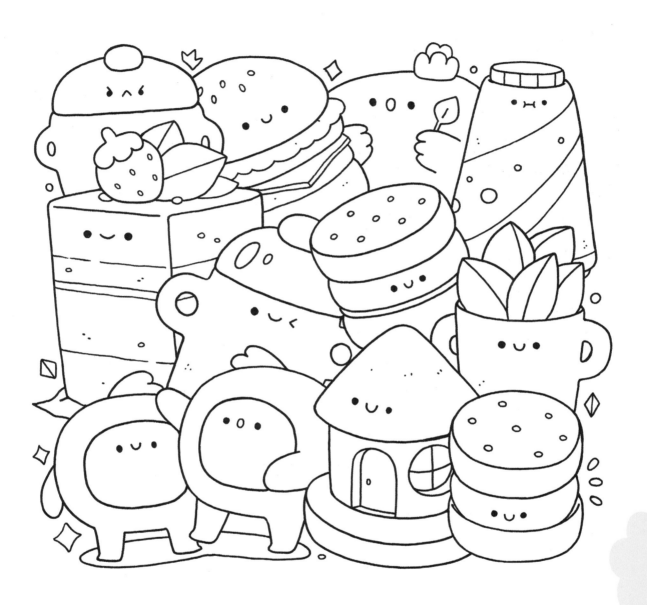

Part 2
Adding
Fun
Decorations

Fruits & Veggies

Characters (Check out the mushroom doodle tutorial on page 119!)

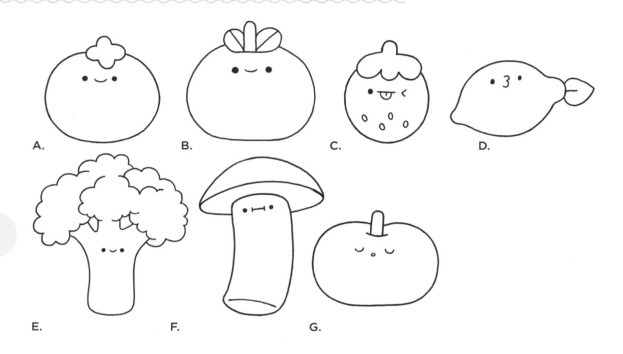

A.

B.

C.

D.

E.

F.

G.

Decorations

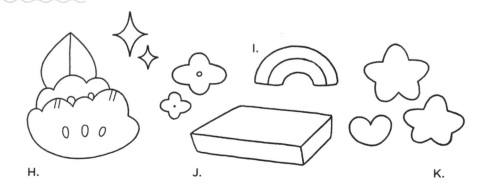

H.

I.

J.

K.

BASIC STEPS

Go for it!

1. Sketching

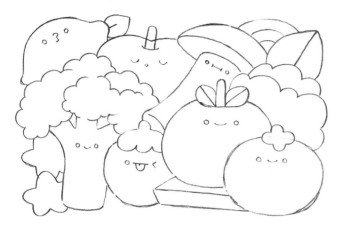

2. Outlining

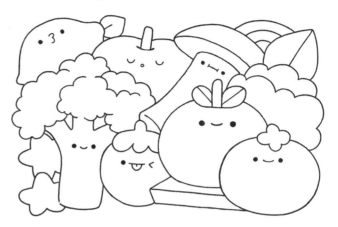

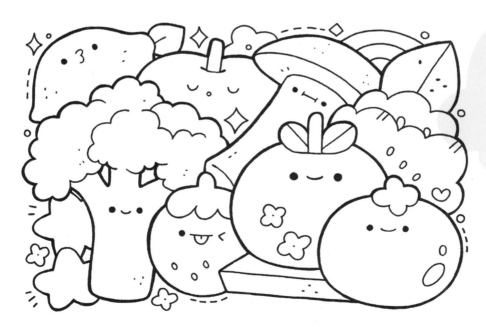

3. Thick Outlining + Adding Details

PRACTICE STEPS

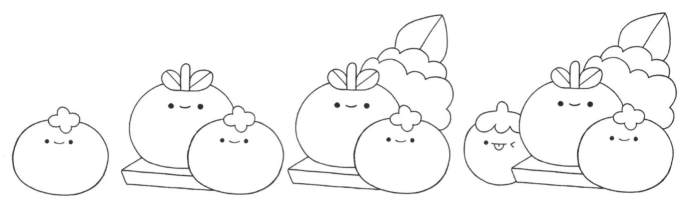

1. For this scene, we're going to work from the bottom to the top in two sections. Draw character A in the bottom-right corner of your scene.

2. Add character B to the left and slightly "behind" character A, placing it on decoration J.

3. Moving up, insert decoration H between the two characters.

4. Draw character C to the left and "behind" character B.

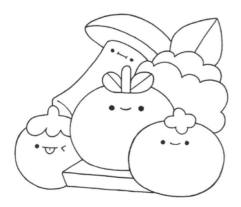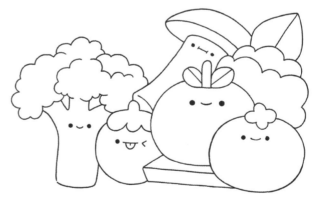

5. Complete the right side of the scene by diagonally drawing in character F to fill the space.

6. Continuing with the left side of scene, place character E to the left of the strawberry.

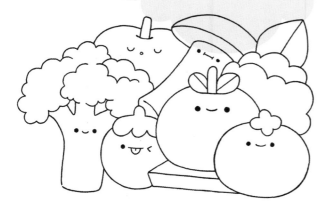

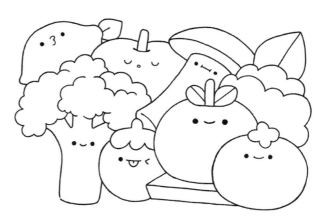

7. Insert character G between the broccoli and mushroom.

8. Add character D to the top-left corner to balance the top of the scene.

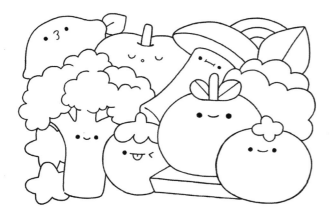

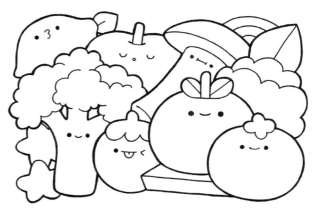

9. Round out the scene with decoration K in the bottom-left corner and decoration I in the top-right corner.

10. Add thick outlining to the main characters so they stand out from the decorations.

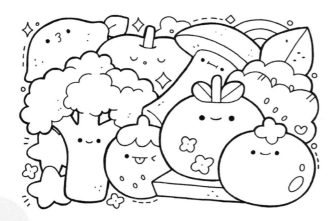

11. Use the remaining decorations to fill in any small spaces along the edges of the scene and to embellish the characters. Finally, draw in the characters' and decorations' finer details and add any additional fun details.

Café Treats

Characters (Check out the donut doodle tutorial on page 124!)

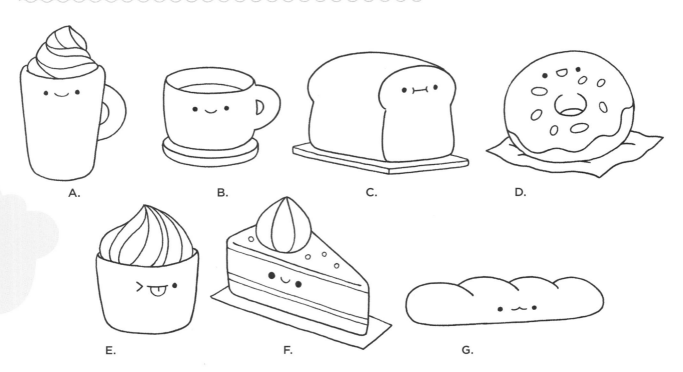

A.

B.

C.

D.

E.

F.

G.

Decorations

H.

I.

J.

K.

L.

M.

N.

O.

BASIC STEPS

1. Sketching

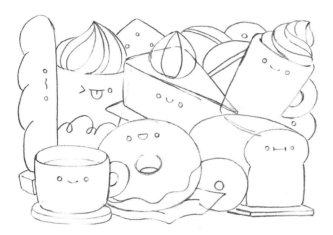

2. Outlining

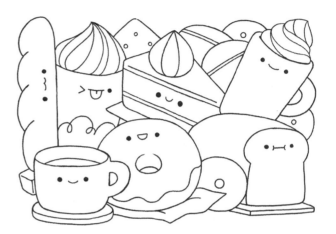

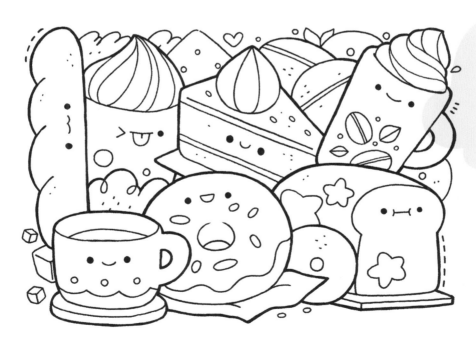

3. Thick Outlining + Adding Details

PRACTICE STEPS

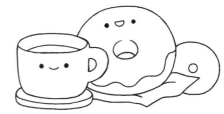

1. For this scene, we're going to work from the bottom to the top. Draw character B in the bottom-left corner of your scene.

2. Add character D to the right and slightly "behind" the coffee mug.

3. To the right of the donut, draw decoration H.

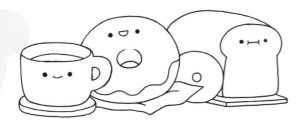

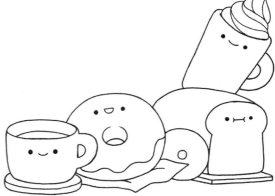

4. Add character C at the far right of the scene to complete the bottom row.

5. Moving up, draw character A at a jaunty right angle.

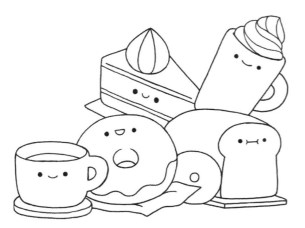

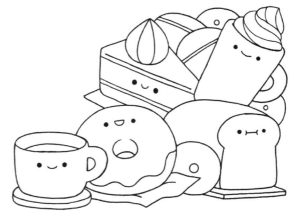

6. Add character F to the left of the character you just drew and angled to the left.

7. Fill in the area between these two characters with decorations I and J. Also place decoration I in the center of the right side of the scene.

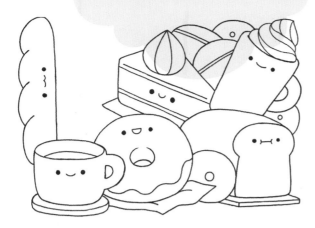

8. Moving to the far-left side of the scene, vertically place character G to establish the left edge of the scene.

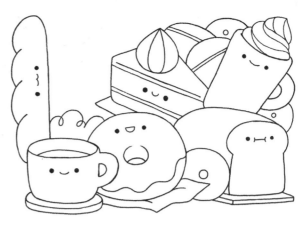

9. Fill in the area between the baguette and donut with decoration L.

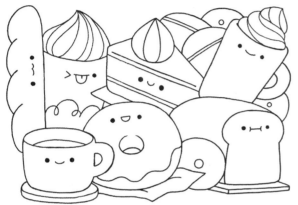

10. Above decoration L, add character E to fill in that area of the scene.

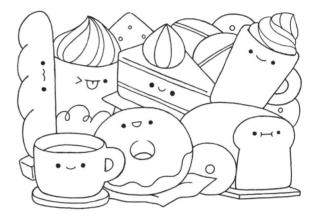

11. Complete the scene by drawing decoration K "behind" the piece of cake and drawing decoration N below the baguette.

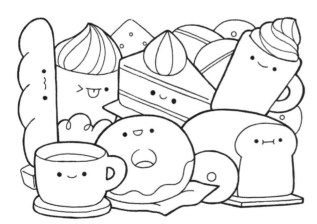

12. Add thick outlining to the main characters so they stand out from the decorations.

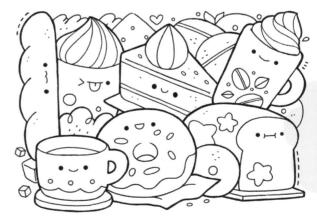

13. Use the remaining decorations to fill in any small spaces along the edges of the scene and to embellish the characters. Finally, draw in any finer details and additional fun details.

Office Supplies

Characters (Check out the clipboard and pencil doodle tutorials on pages 125 and 126!)

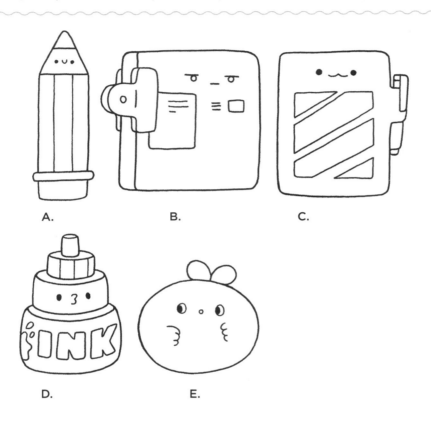

A.　　　　B.　　　　C.

D.　　　　E.

Decorations

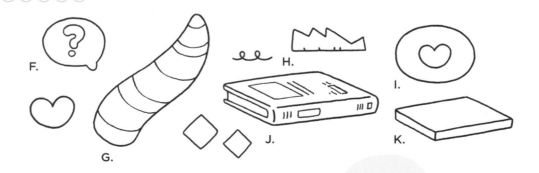

F.

G.　　　H.　　　I.

J.　　　K.

BASIC STEPS

1. Sketching

2. Outlining

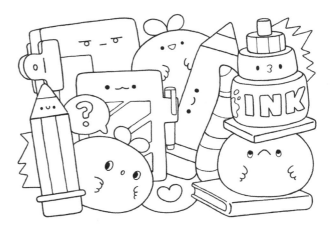

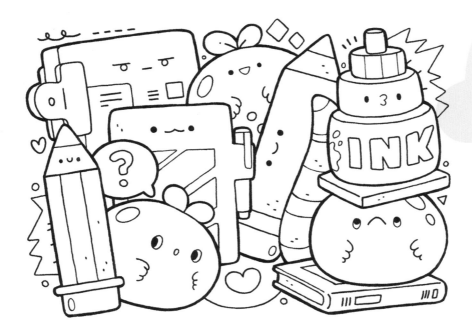

3. Thick Outlining + Adding Details

PRACTICE STEPS

1. For this scene, we're going work from both the bottom and the top. Vertically draw character A in the bottom-left corner of your scene.

2. Add character E to the right of the pencil, as if it is peeking out from "behind" it. Fill in the space between these characters with decoration F.

3. Place character C "behind" character E.

4. Moving to the top-right corner of the scene, add character D on top of decoration K.

 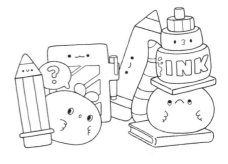

5. Draw decoration J in the bottom-right corner and add another character E, with a different face, on top of decoration J. It should look as if this character is holding the ink bottle above it.

6. Place decoration G along and "behind" the characters on the right side of the scene.

7. Fill in the center of the scene with a second character A, drawn vertically and angled to the right. Note that this pencil doesn't have vertical stripes and the face is on the shaft.

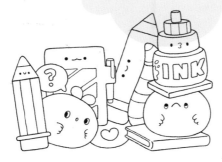

8. Add decoration I to fill in the space at the bottom center of the scene.

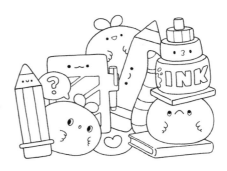

9. Insert a third character E in the top center of the scene. Also give this character a different face from the other two.

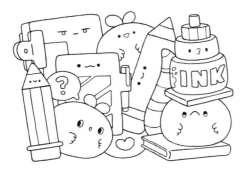

10. Fill in the top-left corner with character B.

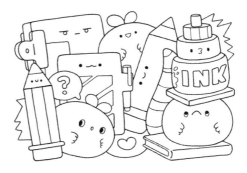

11. In the top-right and bottom-left corners, add decoration H.

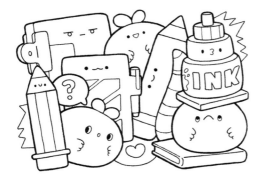

12. Add thick outlining to the main characters so they stand out from the decorations.

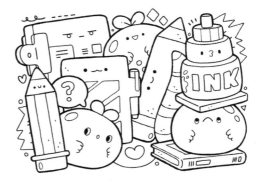

13. Use the remaining decorations to fill in any small spaces along the edges of the scene and to embellish the characters. Finally, draw in the characters' and decorations' finer details and add any additional fun details.

Potted Plants

Characters (Check out the potted plant doodle tutorial on page 127!)

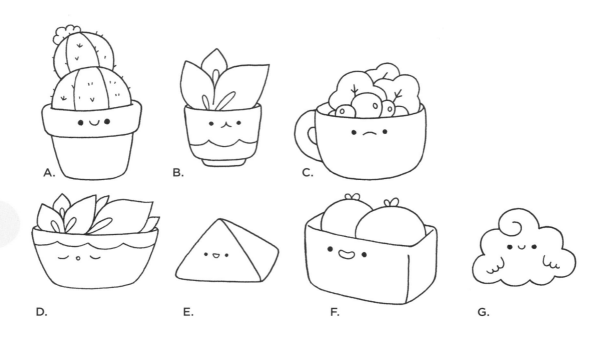

A.

B.

C.

D.

E.

F.

G.

Decorations

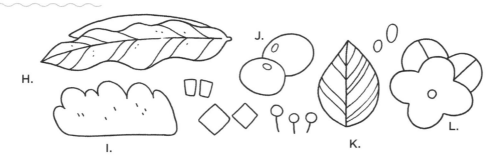

H.

I.

J.

K.

L.

BASIC STEPS

1. Sketching

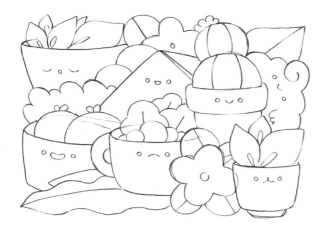

2. Outlining

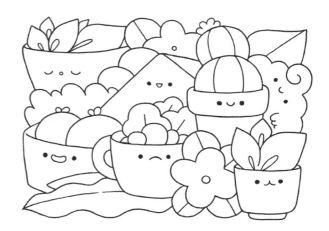

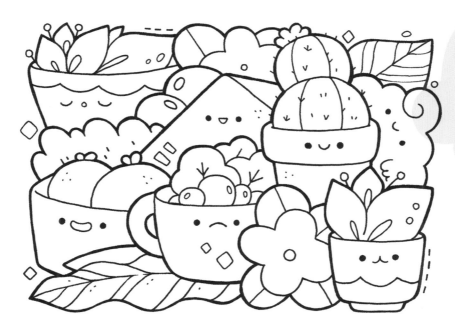

3. Thick Outlining + Adding Details

PRACTICE STEPS

1. For this scene, we're going to build the right side and then the left side. Draw character B in the bottom-right corner of your scene.

2. Add decoration L to the left and slightly "behind" this potted plant.

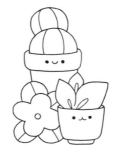

3. Moving up, place character A between the flower and the potted plant.

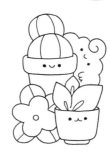

4. Draw character G along the right side of the cactus.

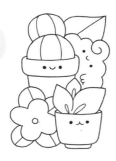

5. Fill in the space above the cloud with decoration K.

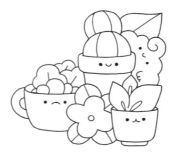

6. Moving to the left side of the scene, draw character C.

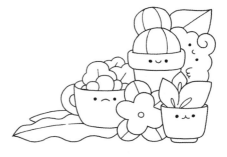

7. Fill in the space below this character with decoration H, having it extend to the bottom-left corner.

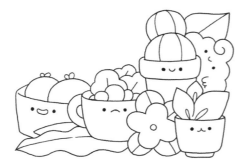

8. Place character F in the bottom-left corner "behind" the palm frond.

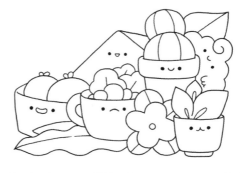

9. Moving up, fill in the center part of the scene with character E.

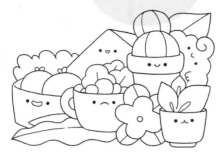

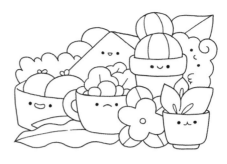

10. Add decoration I to the left side of the scene.

11. Along the left side of the pyramid, draw decoration J.

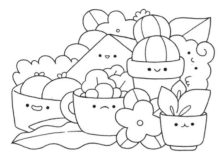

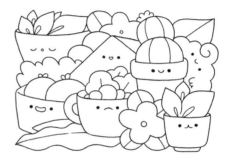

12. Fill in the space at the top center with a second decoration L.

13. Round out the scene by placing character D in the top-left corner.

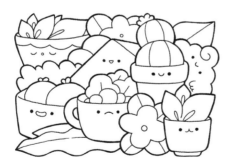

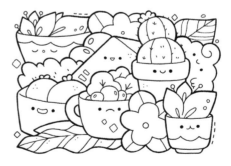

14. Add thick outlining to the main characters so they stand out from the decorations.

15. Use the remaining decorations to fill in any small spaces along the edges of the scene and to embellish the characters. Finally, draw in the characters' and decorations' finer details and add any additional fun details.

Crystals

Characters (Check out the doodle monster tutorials on pages 122 and 123!)

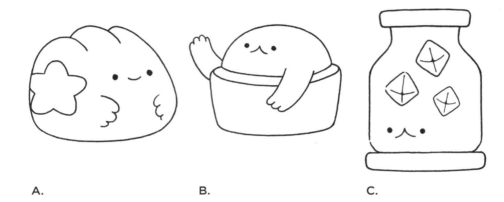

A.

B.

C.

Decorations

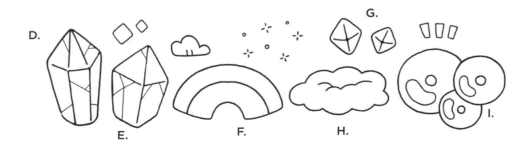

D.

E.

F.

G.

H.

I.

BASIC STEPS

Doodle Party!

1. Sketching

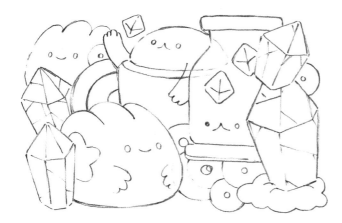

2. Outlining

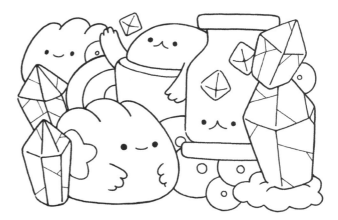

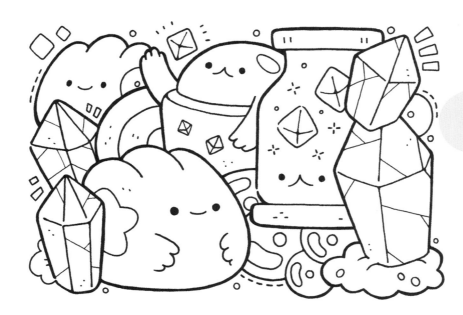

3. Thick Outlining + Adding Details

PRACTICE STEPS

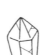

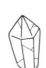

1. For this scene, we're going to establish the right and left edges of the scene, and then build it from there. Draw decoration D in the bottom-left corner of your scene.

2. Add decoration E to the top-right corner.

3. Based on the styles of the first two decorations, draw a third, larger version below the one in the top-right corner. Have its base sit "in" decoration H.

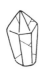

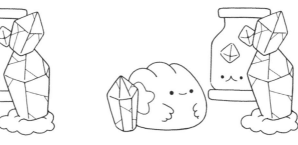

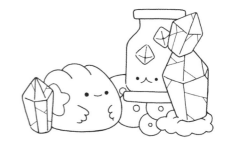

4. Place character C to the left and "behind" the crystals at the right side of the scene.

5. Draw character A to the right and "behind" the crystal in the bottom-left corner.

6. Fill in the space below character C with decoration I.

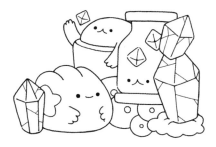

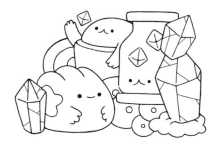

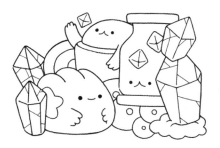

7. Add character B to the left of the jar. Place decoration G above its raised arm.

8. Extend decoration F from this doodle monster to the top of the other doodle monster.

9. Draw another decoration D above and "behind" the first one.

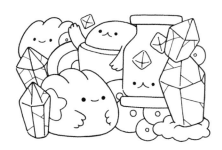

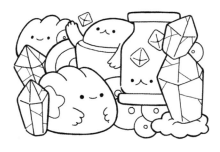

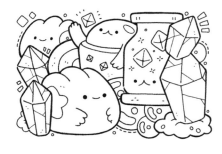

10. Round out the scene by adding another, smaller version of character A and place a circle from decoration I to the right of this character and another between the crystals on the right side of the scene.

11. Add thick outlining to the main characters so they stand out from the decorations.

12. Use the remaining decorations to fill in any small spaces along the edges of the scene and to embellish the characters. Finally, draw in the decorations' finer details and add any additional fun details.

GET INSPIRED!

Here are some more decorations to doodle into a fun scene. You just need to add the characters. Are you up for the challenge?

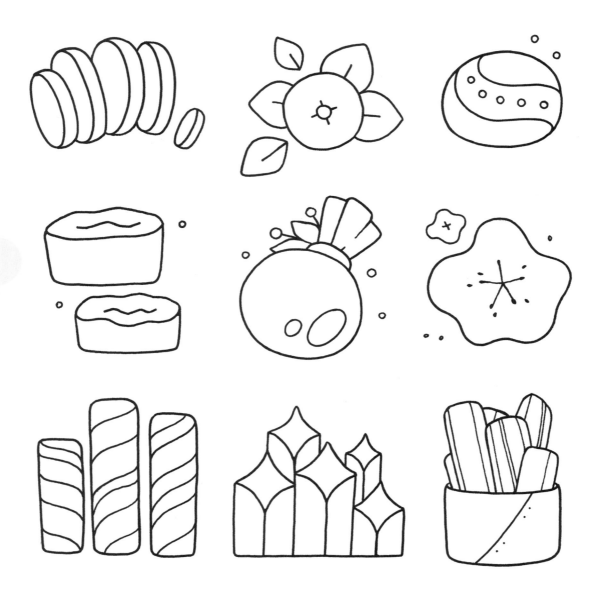

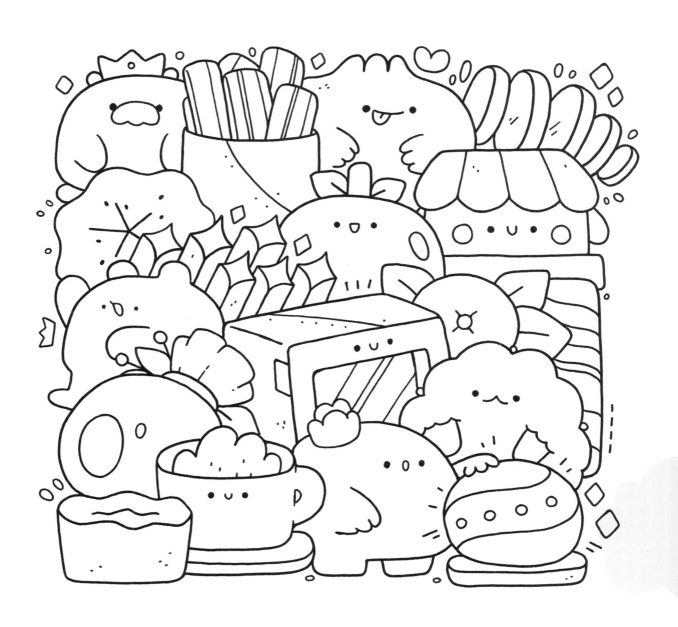

Part 3
Adding
Whimsical
Patterns

Outer Space

Characters (Check out the planet and star doodle tutorials on pages 128 and 129!)

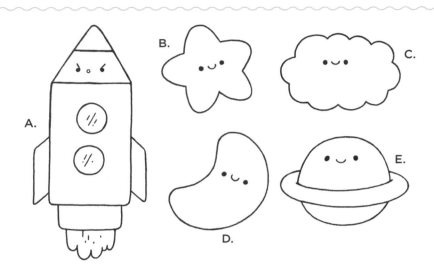

A.
B.
C.
D.
E.

Decorations

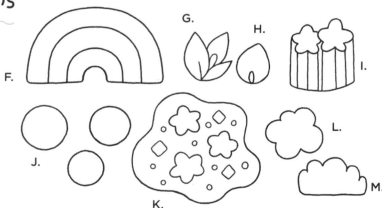

F.
G.
H.
I.
J.
K.
L.
M.

Patterns

BASIC STEPS

Keep on drawing!

1. Sketching

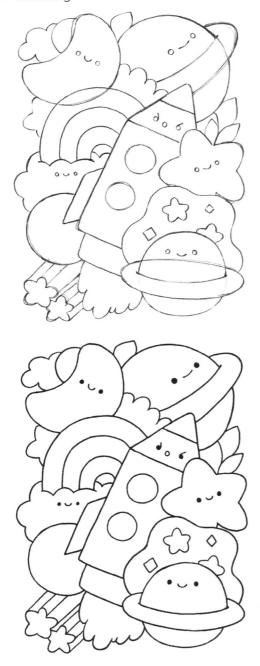

2. Outlining

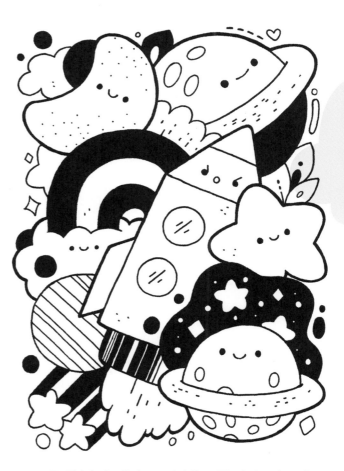

3. Thick Outlining + Adding Black (optional)
 + Adding Details + Patterns

PRACTICE STEPS

 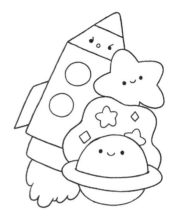

1. For this scene, we're going to work from the bottom to the top. Draw character E on the bottom-right side of the scene.

2. Add decoration K "behind" the planet.

3. Moving up, draw character B "behind" decoration K.

4. Align character A along the left sides of the first three characters.

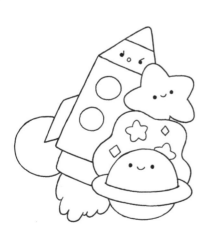 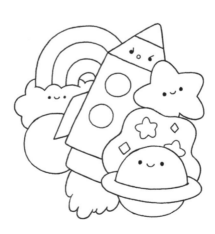 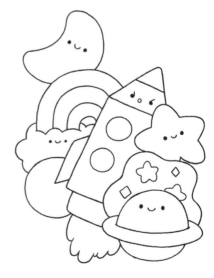

5. Draw the largest circle of decoration J coming off the left side of the rocket.

6. Fill in the area above this circle with character C and have decoration F coming out of the top of it.

7. Balance character D on top of the rainbow to establish the top-left corner of the scene.

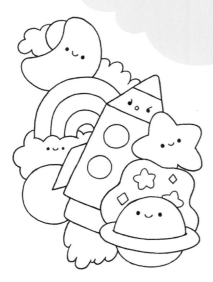

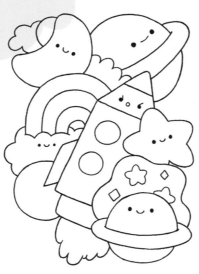

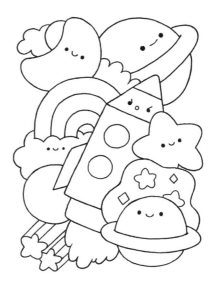

8. Surround the moon with decorations L and M, having a smaller circle of decoration J coming out of the left side of the moon.

9. Fill in the top-right corner of the scene with a larger version of character E.

10. Add decoration I to fill in the space in the bottom-left corner.

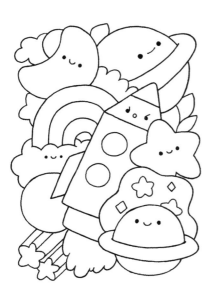

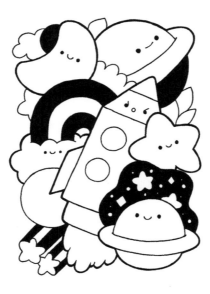

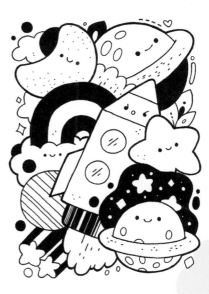

11. Round out the edges of the scene with decoration L between the moon and rainbow on the left, decoration G between the larger planet and star on the right, and decoration H between the moon and larger planet at the top.

12. Add thick outlining to the main characters so they stand out from the decorations and color in sections in black.

13. Use the remaining decorations and patterns to fill in any small spaces along the edges of the scene and to embellish the characters. Finally, draw in the characters' finer details and add any additional fun details.

More Doodle Monsters

Characters (Check out the doodle monster tutorials on pages 122 and 123!)

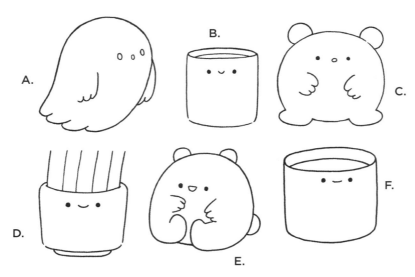

A.

B.

C.

D.

E.

F.

Decorations

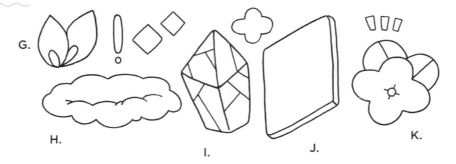

G.

H.

I.

J.

K.

Patterns

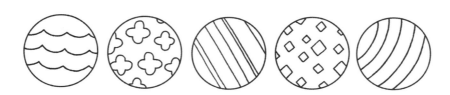

BASIC STEPS

Draw one step at a time!

1. Sketching

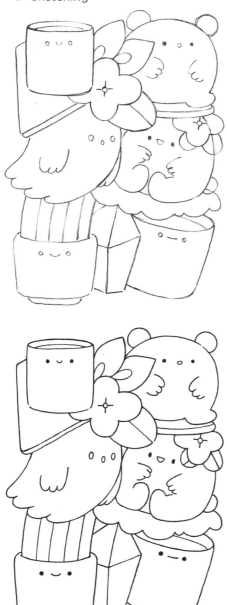

2. Outlining

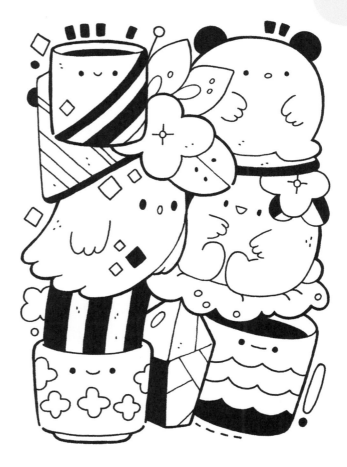

3. Thick Outlining + Adding Black (optional)
 + Adding Details + Patterns

Adding Whimsical Patterns 61

PRACTICE STEPS

1. For this scene, we're going to work from the top to the bottom. Draw character B in the top-left corner of your scene.

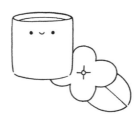

2. Add decoration K off the bottom-right corner of this character.

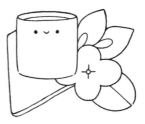

3. Draw decoration J below the character and add decoration G to the top of decoration K.

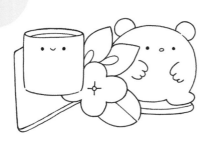

4. Fill in the top-right corner of the scene with character C, adding a round platform below it.

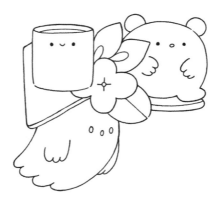

5. Place character A below the objects on the left side.

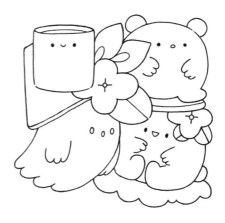

6. Draw character E beneath character C on the right and set it on decoration H. Add another decoration K to the right side of this doodle monster's head.

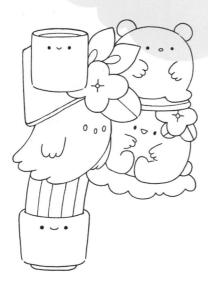

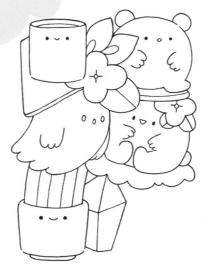

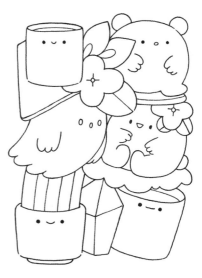

7. Fill in the bottom-left corner of the scene with character D.

8. Add decoration I to the right of this character.

9. Round out the scene with character F filling the bottom-right corner.

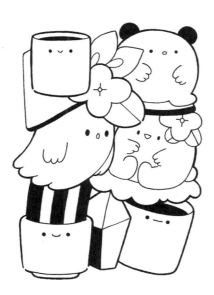

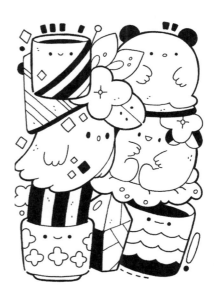

10. Add thick outlining to the main characters so they stand out from the decorations and color in sections in black.

11. Use the remaining decorations and patterns to fill in any small spaces along the edges of the scene and to embellish the characters. Finally, draw any of the characters' and decorations' finer details and add any additional fun details.

Snack Time

Characters (Check out the doodle monster tutorials on pages 122 and 123!)

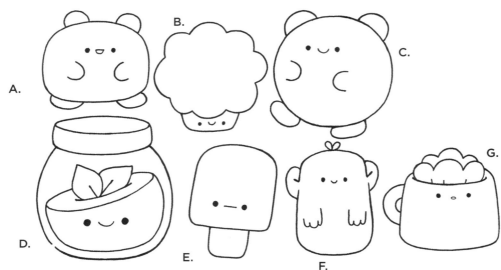

A. B. C. D. E. F. G.

Decorations

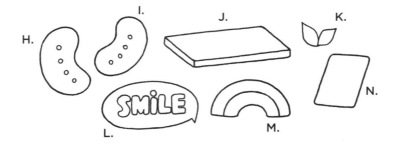

H. I. J. K. L. M. N.

Patterns

BASIC STEPS

You're getting good at this!

1. Sketching

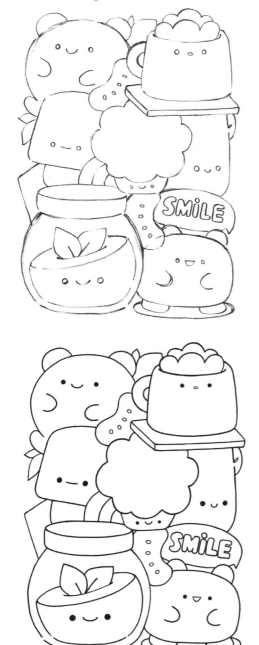

2. Outlining

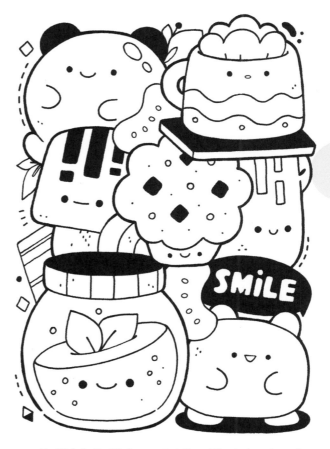

3. Thick Outlining + Adding Black (optional)
 + Adding Details + Patterns

PRACTICE STEPS

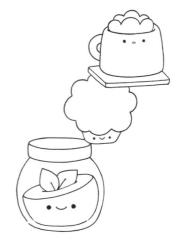

1. For this scene, we're going to work diagonally from the top right to the bottom left and build from there. Draw character G at in the top-right corner of the scene, on top of decoration J.

2. Add character B below and to the left of character G.

3. Place character D in the bottom-left corner of the scene.

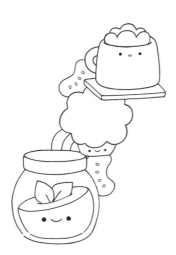

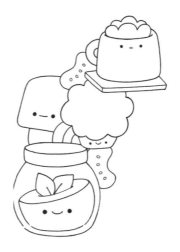

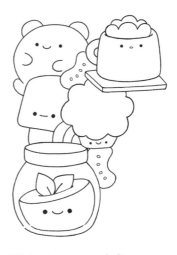

4. Surround these characters with decorations H, I, and M.

5. Draw character E to the left of character B and the rainbow.

6. Fill in the upper-left corner with character C.

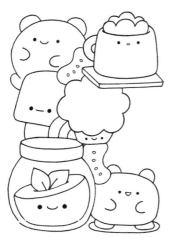

7. Place character A in the lower-right corner on a circle.

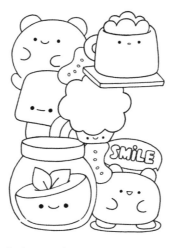

8. Insert decoration L above this character's head.

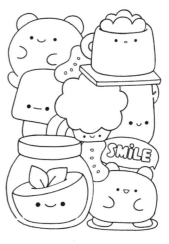

9. Fill in the open space in the center right with character F, moving his face down and not adding arms.

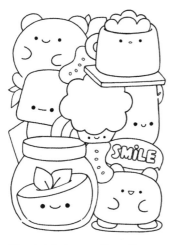

10. Add decoration K to fill in the small spaces at the top and left side of the scene. Also use decoration N to fill out the space at the left edge.

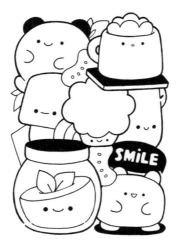

11. Add thick outlining to the main characters so they stand out from the decorations and color in sections in black.

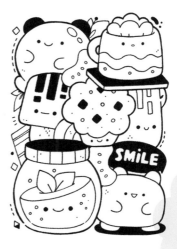

12. Use the remaining decorations and patterns to fill in any small spaces along the edges of the scene and to embellish the characters. Finally, add any additional fun details.

Kitchen Friends

Characters (Check out the doodle monster tutorials on pages 122 and 123!)

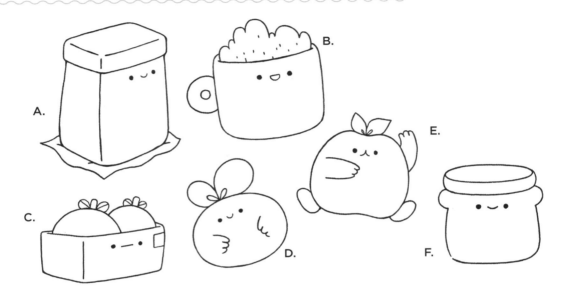

A.

B.

E.

C.

D.

F.

Decorations

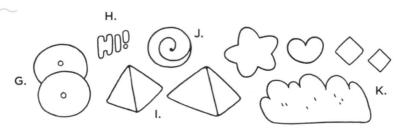

G.

H.

HI!

J.

I.

K.

Patterns

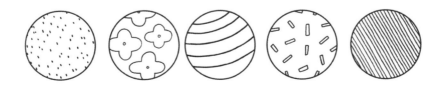

BASIC STEPS

1. Sketching

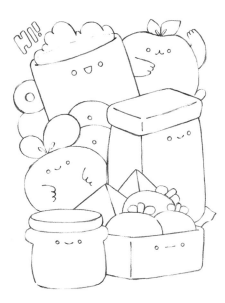

2. Outlining

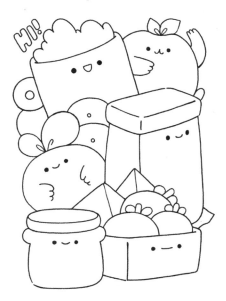

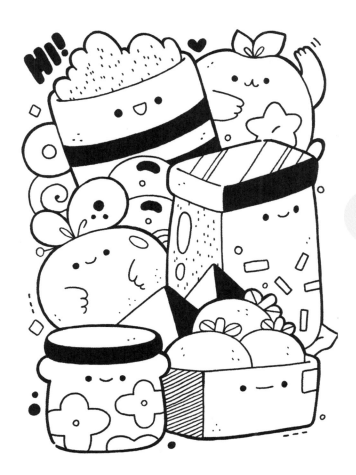

3. Thick Outlining + Adding Black (optional)
 + Adding Details + Patterns

PRACTICE STEPS

1. For this scene, we're going to work from the bottom to the top. Draw character F in the bottom-left corner of your scene.

2. Add character C to the right of the jar, adding a third piece of fruit to it.

3. Place decoration I "behind" the fruit.

4. Add height to the scene by placing character A along the right edge of the scene. Draw what looks like a cloth underneath it.

5. Moving up the left side of the scene, add character D.

6. Fill in the space between this character and character A with decoration G.

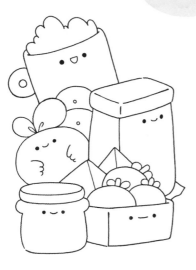

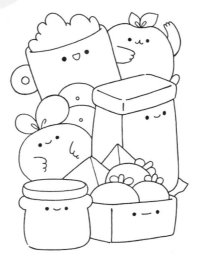

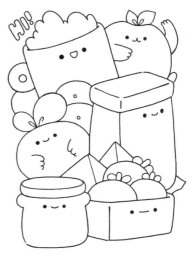

7. Moving up again, draw character B in the top-left corner.

8. Round out the scene in the top-right corner with character E.

9. Fill in small spaces on the left edge with decorations H and J.

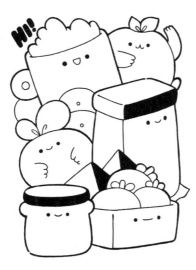

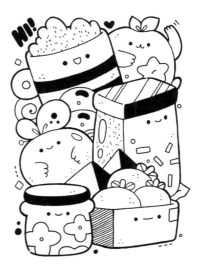

10. Add thick outlining to the main characters so they stand out from the decorations and color in sections in black.

11. Use the remaining decorations and patterns to fill in any small spaces along the edges of the scene and to embellish the characters. Finally, draw any of the characters' and decorations' finer details and add any additional fun details.

GET INSPIRED!

Here are some more patterns to doodle into a fun scene. You just need to add the characters and decorations. You can do it!

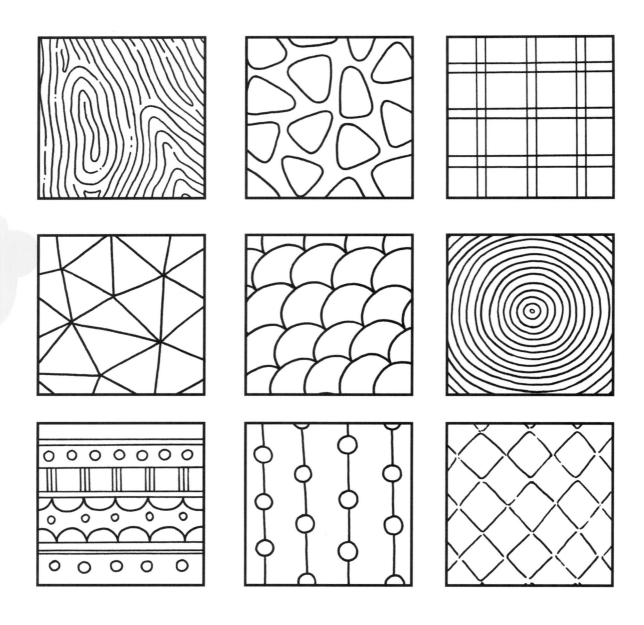

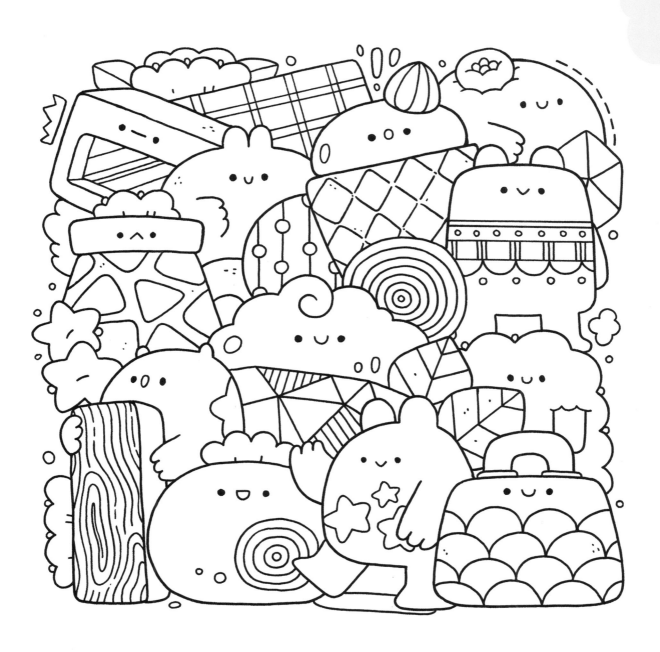

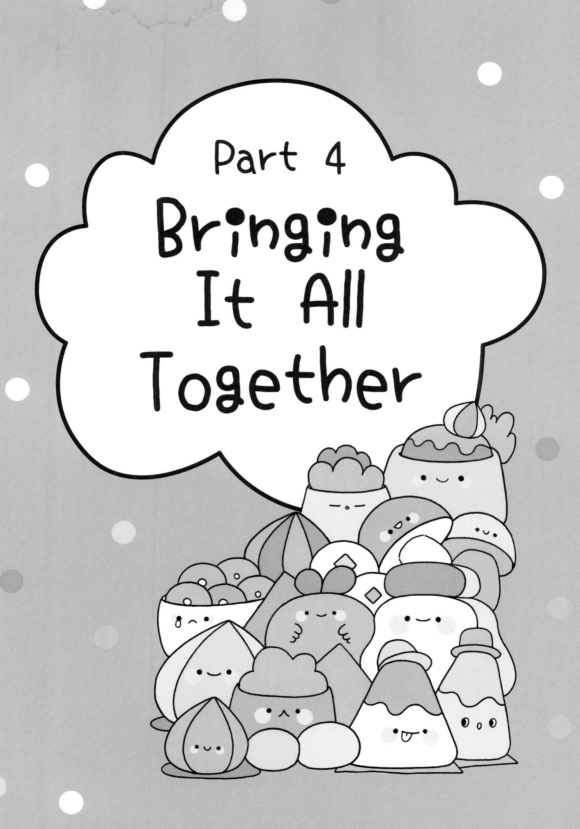

Part 4
Bringing It All Together

Doodle 1

Characters (Check out the mushroom doodle tutorial on page 119!)

Decorations

Patterns

BASIC STEPS

Keep at it!

1. Sketching (the numbered sketch to the right shows the order I drew the characters and decorations)

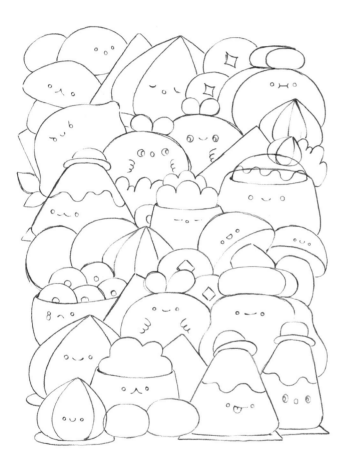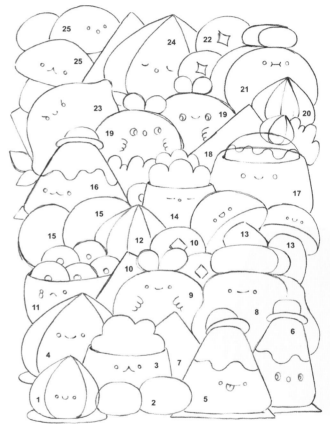

BASIC STEPS (continued)

2. Outlining

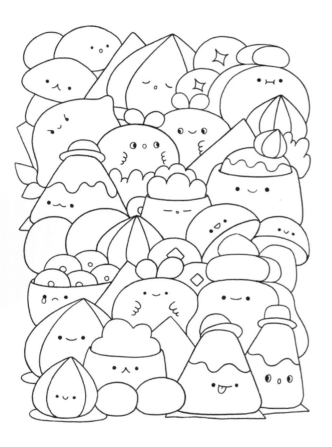

3. Thick Outlining + Adding Black (optional)

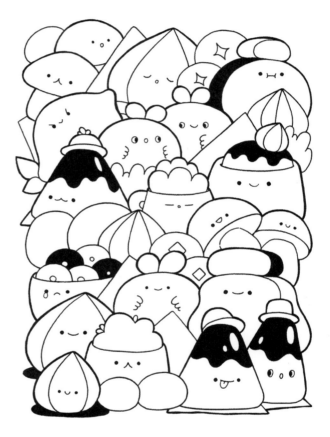

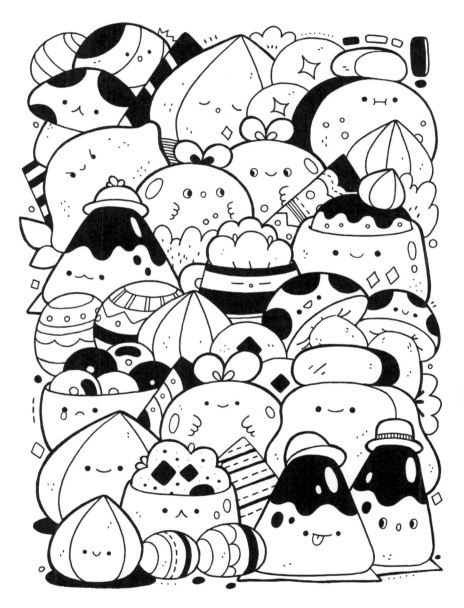

4. Adding Details + Patterns

Doodle 2

Characters (Check out the cloud doodle tutorial on page 12!)

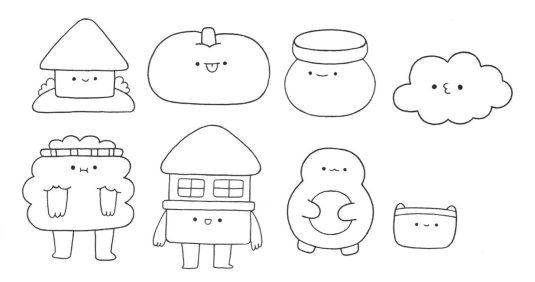

Decorations

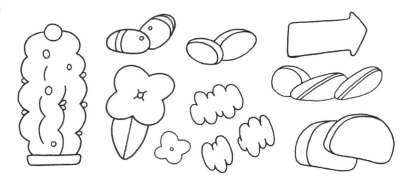

Patterns

BASIC STEPS

I like your style!

1. Sketching (the numbered sketch to the right shows the order I drew the characters and decorations)

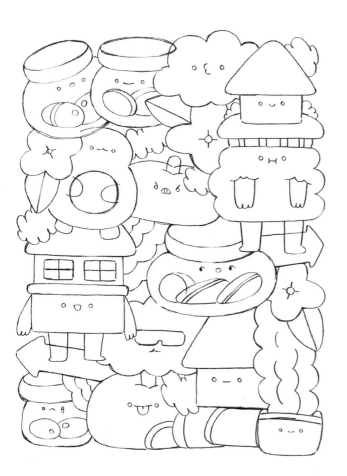

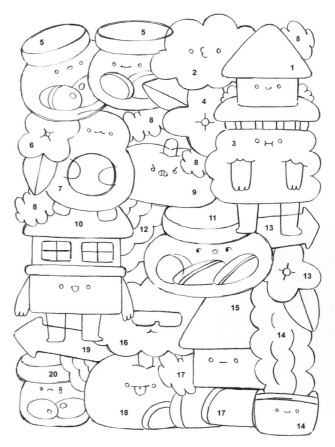

BASIC STEPS (continued)

2. Outlining

3. Thick Outlining

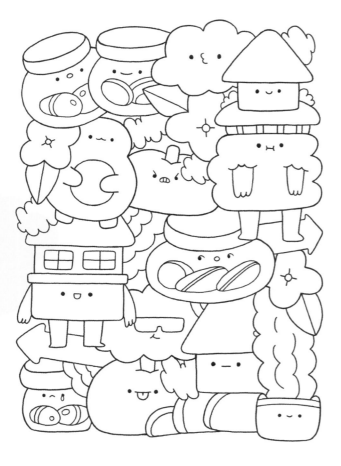

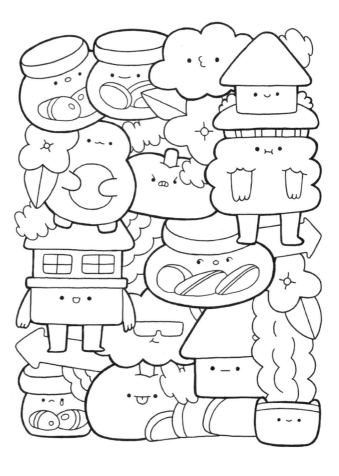

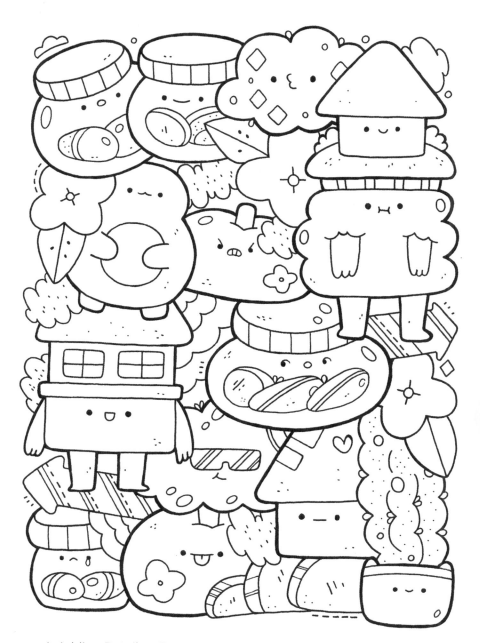

4. Adding Details + Patterns

Doodle 3

Characters (Check out the doodle monsters tutorials on pages 122 and 123!)

Decorations

Patterns

BASIC STEPS

1. Sketching (the numbered sketch below shows the order I drew the characters and decorations)

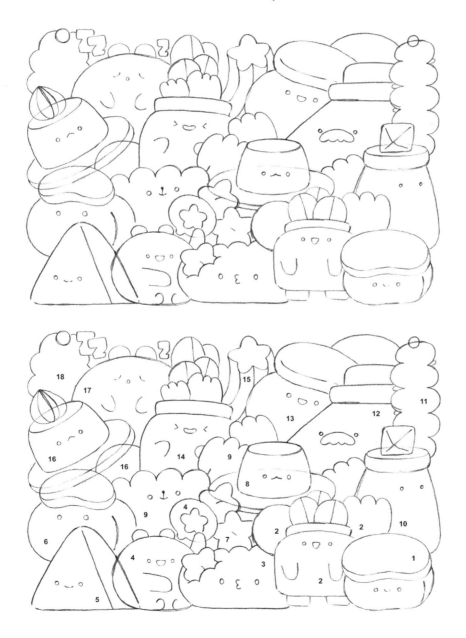

2. Outlining

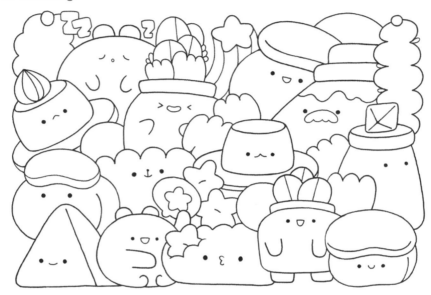

3. Thick Outlining

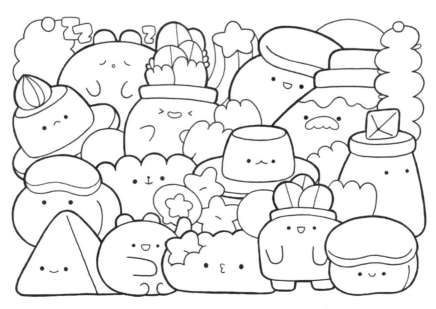

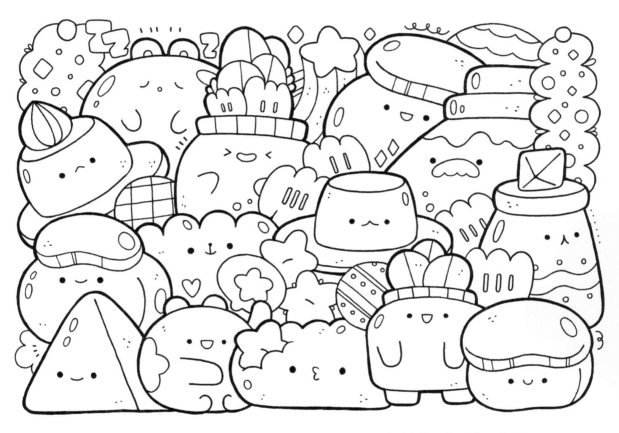

4. Adding Details + Patterns

Doodle 4

Characters (Check out the doodle monsters and potted plant tutorials on pages 122, 123, and 127!)

Decorations

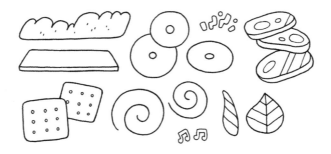

Patterns

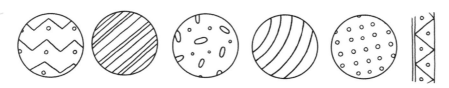

BASIC STEPS

1. Sketching (the numbered sketch below shows the order I drew the characters and decorations)

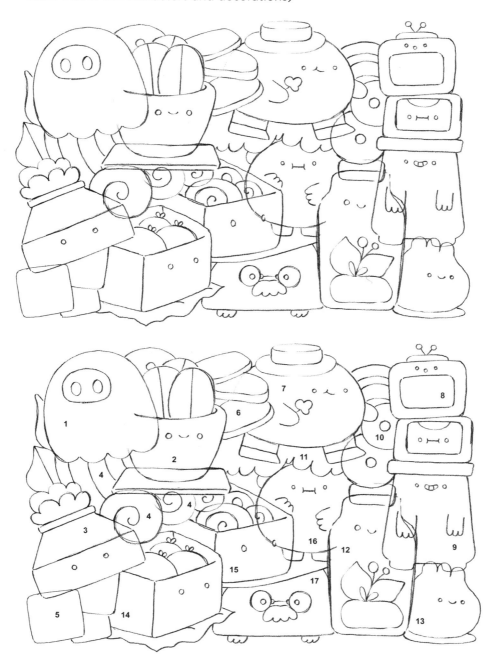

2. Outlining

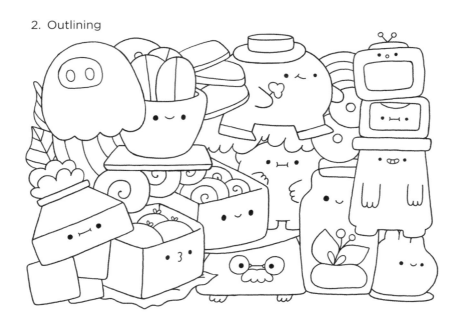

3. Thick Outlining + Adding Black (optional)

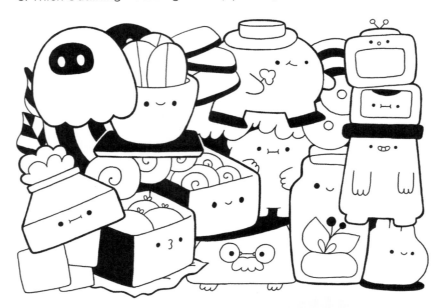

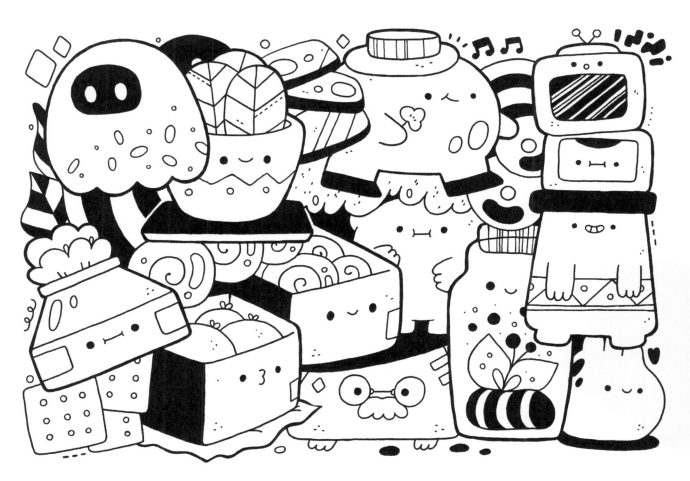

4. Adding Details + Patterns

GET INSPIRED!

Coming up with a theme to doodle can be a lot of fun, like these two party themes: a doodle party and a birthday party!

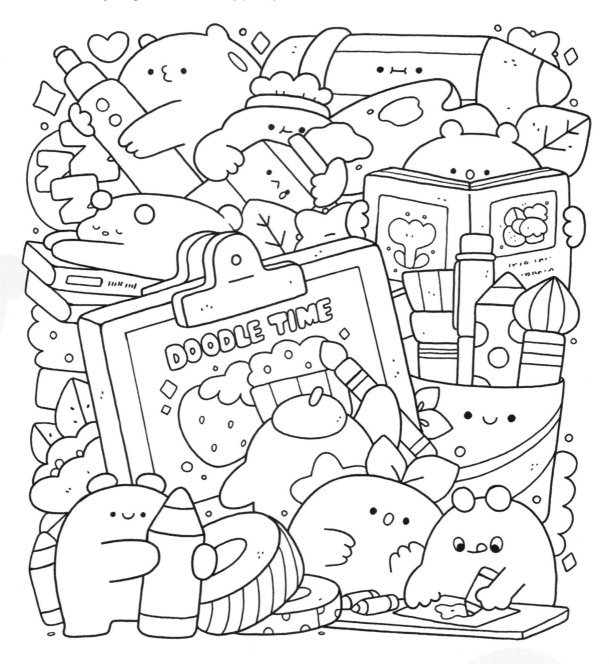

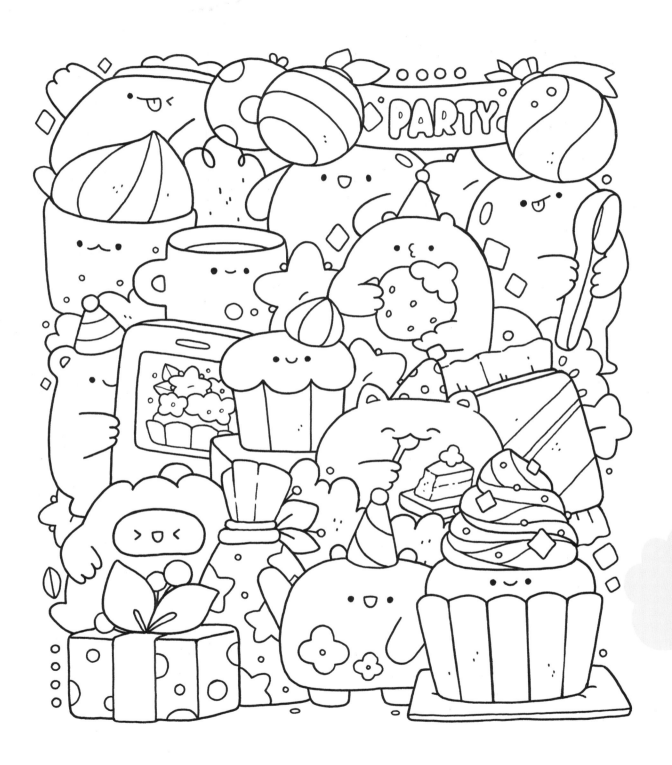

Part 5
Creating Shaped Doodles

Circle Doodle

Characters (Check out the doodle monster tutorials on pages 122 and 123!)

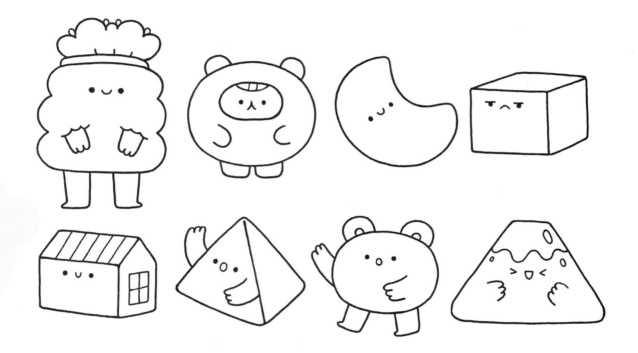

Decorations

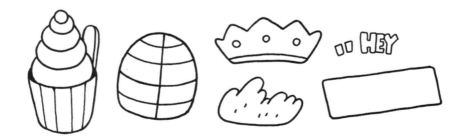

HEY

BASIC STEPS

1. Sketching the Shape

2. Sketching the Doodle (the numbered sketch on the next page shows the order I drew the characters and decorations)

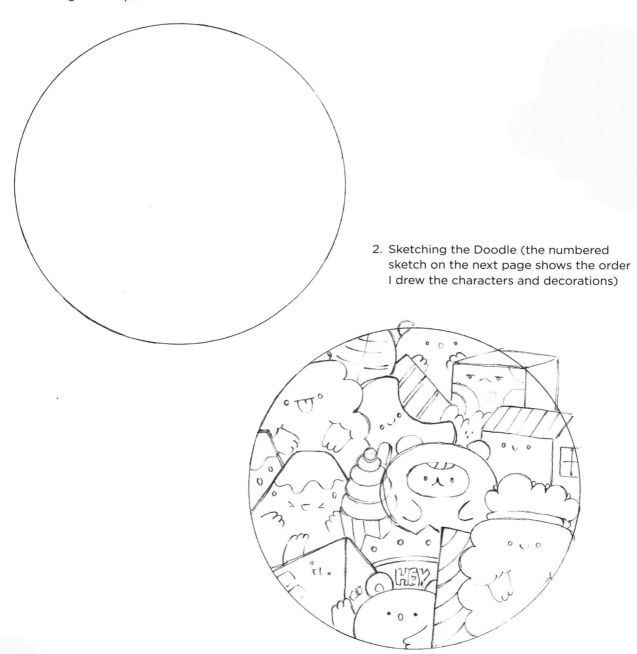

BASIC STEPS (continued)

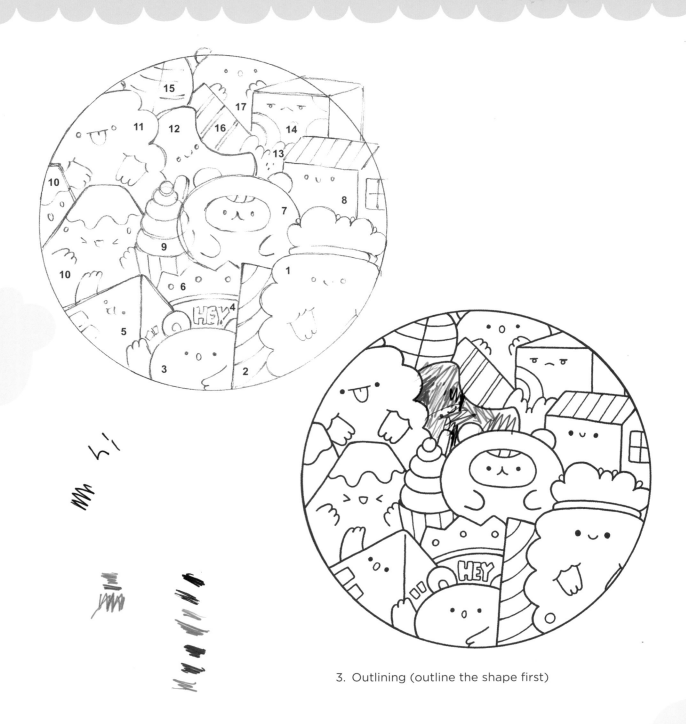

3. Outlining (outline the shape first)

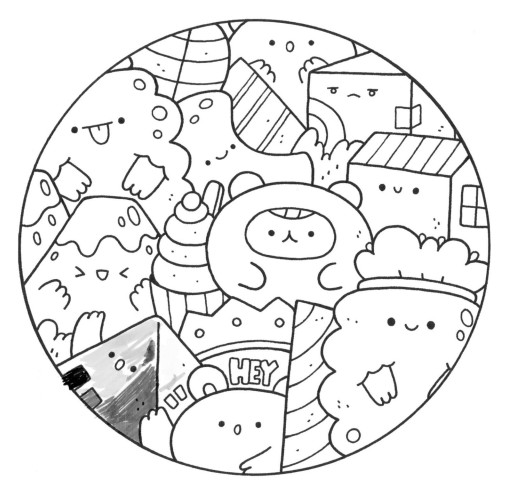

4. Adding Details

Star Doodle

Characters (Check out the star doodle tutorial on page 129!)

Decorations

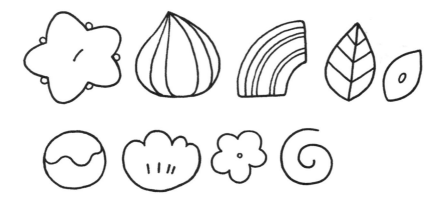

BASIC STEPS

1. Sketching the Shape

2. Sketching the Doodle (the numbered sketch on the next page shows the order I drew the characters and decorations)

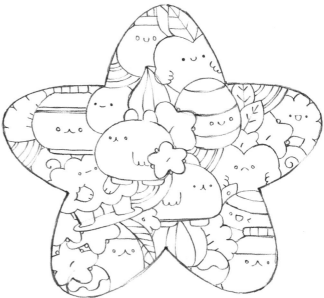

BASIC STEPS (continued)

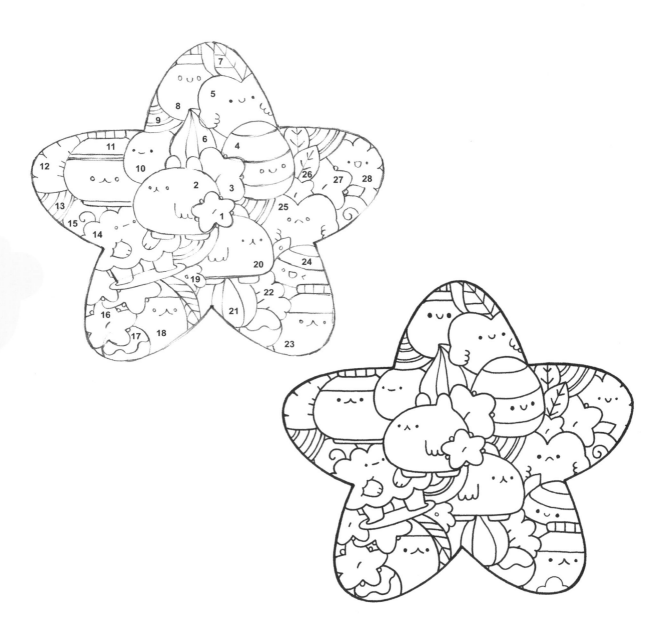

3. Outlining (outline the shape first)

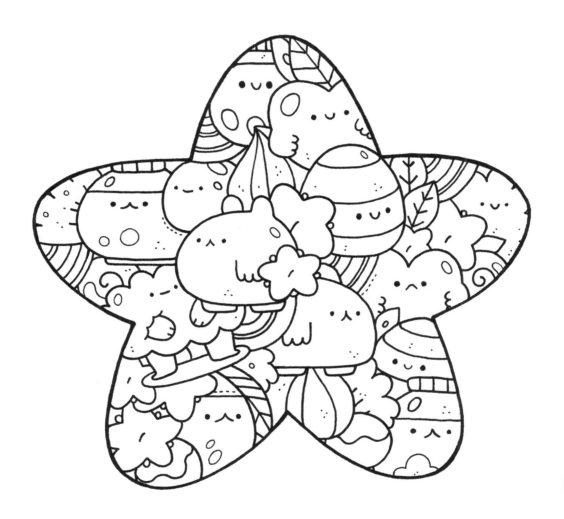

4. Adding Details

Heart Doodle

Characters (Check out the cupcake tutorial on page 120!)

Decorations

BASIC STEPS

1. Sketching the Shape

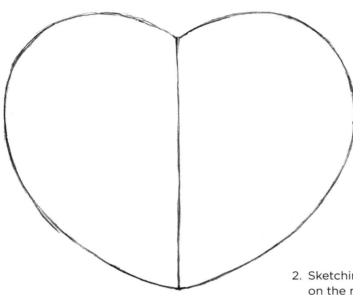

2. Sketching the Doodle (the numbered sketch on the next page shows the order I drew the characters and decorations)

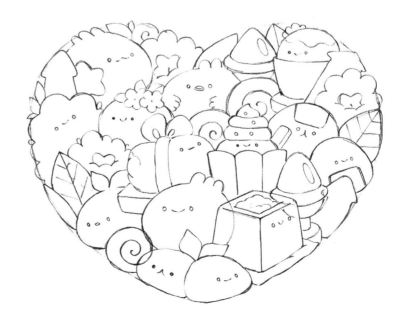

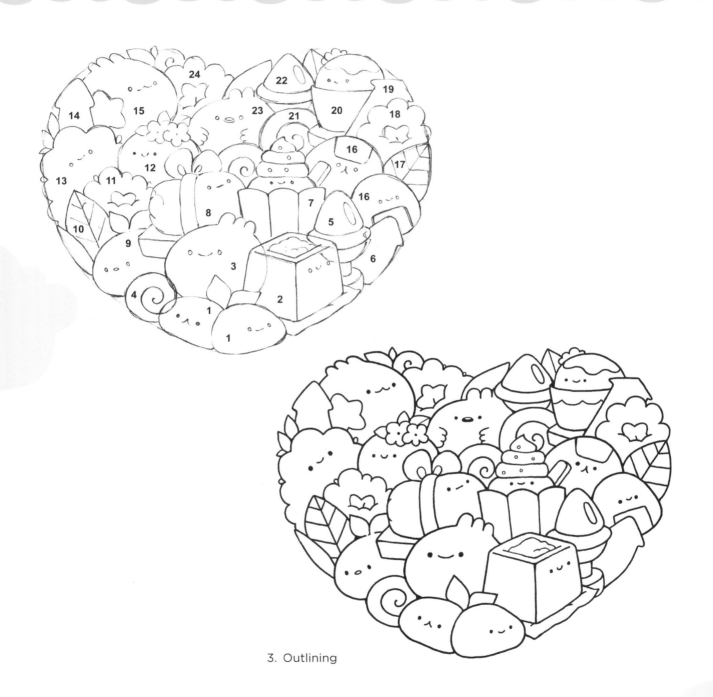

3. Outlining

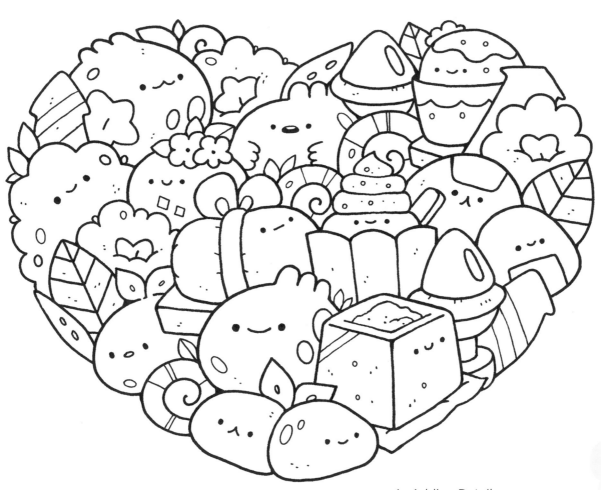

4. Adding Details

Moon Doodle

Characters (Check out the cloud tutorial on page 12!)

Decorations

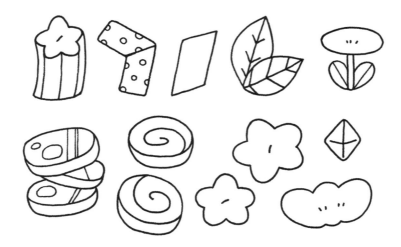

BASIC STEPS

1. Sketching the Shape

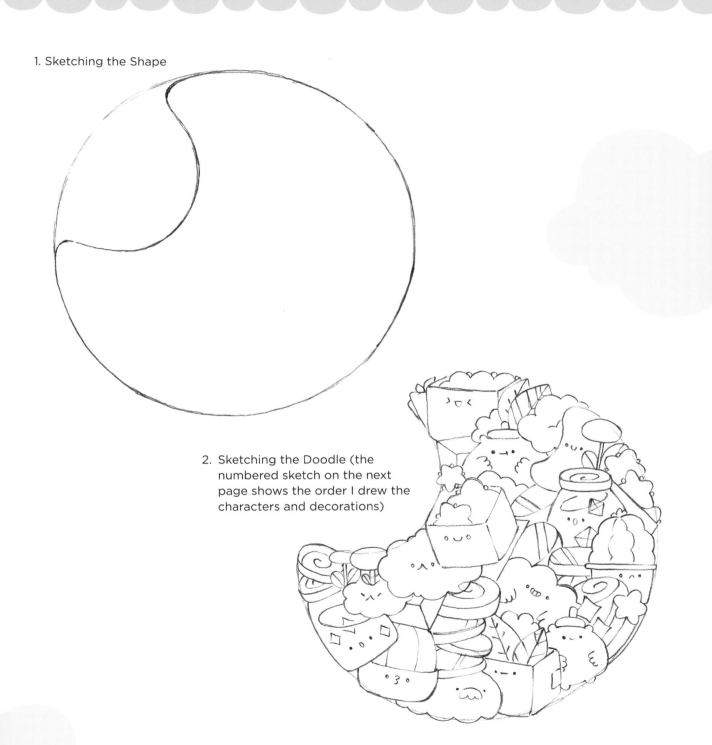

2. Sketching the Doodle (the numbered sketch on the next page shows the order I drew the characters and decorations)

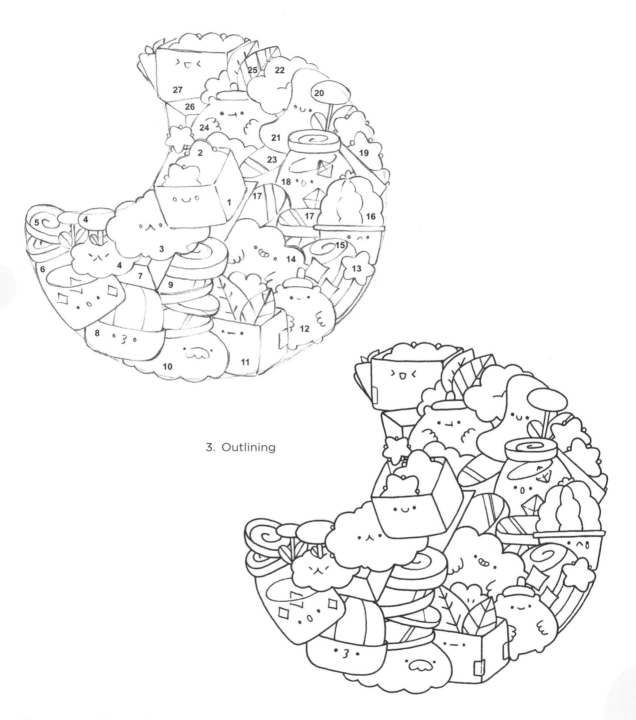

3. Outlining

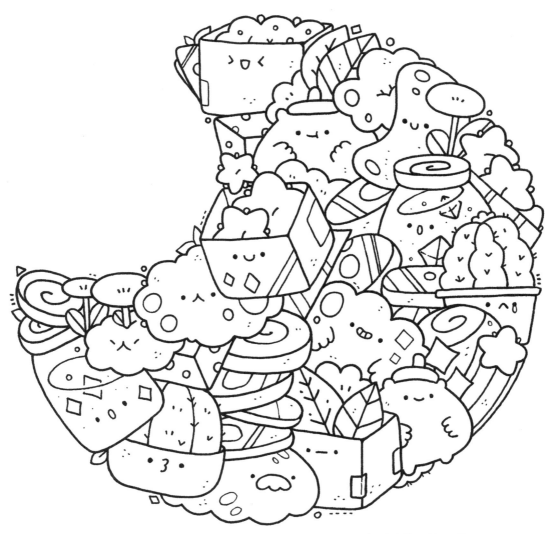

4. Adding Details

Hi! Doodle

Characters (Check out the cupcake, doodle monster, and potted plant tutorials on pages 120, 122, and 127!)

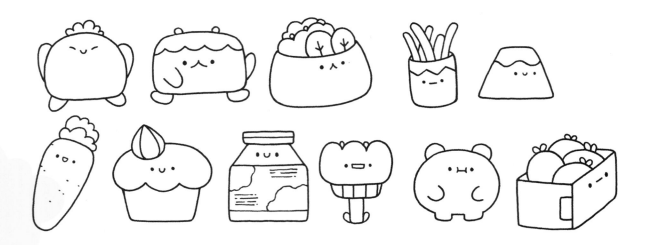

Decorations

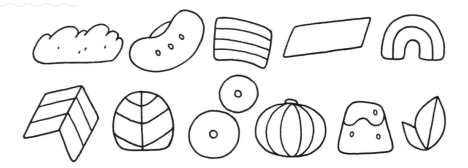

BASIC STEPS

I can't wait to see your own doodles!

1. Sketching the Shape

2. Sketching the Doodle (the numbered sketch on the next page shows the order I drew the characters and decorations)

BASIC STEPS (continued)

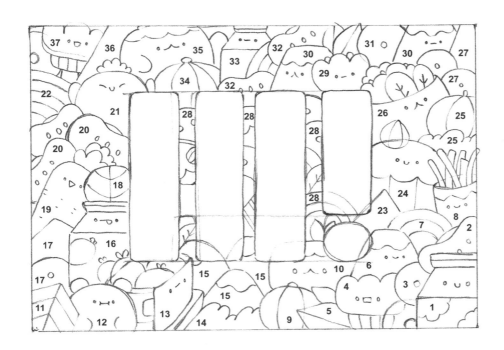

3. Outlining (outline
 the shapes first)

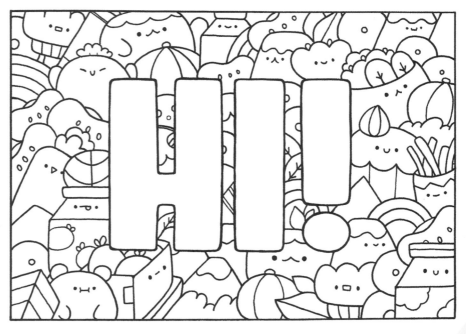

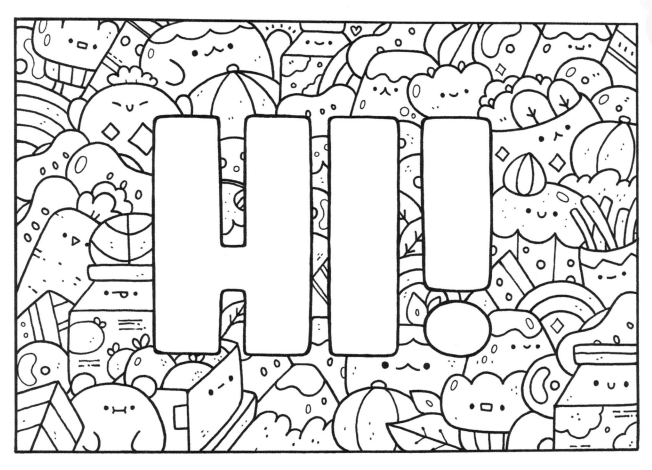

4. Adding Details

GET INSPIRED!

Here are some more doodle shapes to get you thinking. What other shapes and words could you incorporate into a doodle scene?

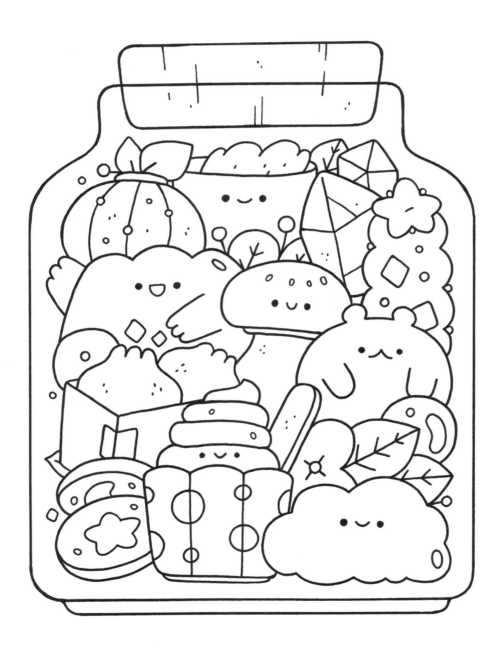

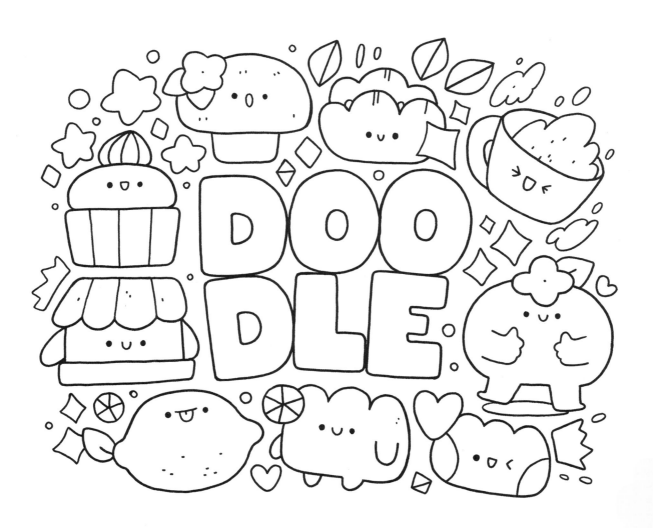

Kawaii Doodle Refresher Course

HOW TO DRAW A Mushroom

1. Draw a fat triangle with rounded points.

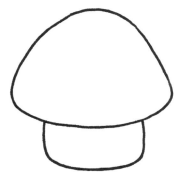

2. Draw a wide stem so you can add a face. Make sure the corners are rounded!

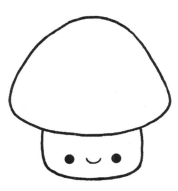

3. Draw a cute face, of course!

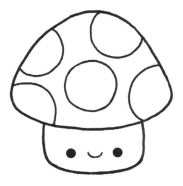

4. Decorate your mushroom! I drew circles and semicircles.

HOW TO DRAW A Cupcake

1. Draw a straight line with two slanted lines coming up from it.

2. Complete the liner with a pretty scalloped edge.

3. Draw short curved lines in from the edges of the liner.

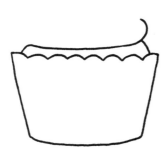

4. Now it's time to draw the swirling frosting! Connect the left curved line to the right one, then swoop up with your pen.

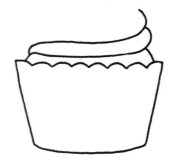

5. Draw another swooping line.

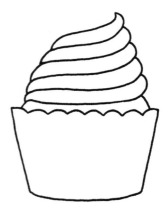

6. Draw four more swooping lines. These lines will be a little curvier than the first two lines and will get increasingly shorter.

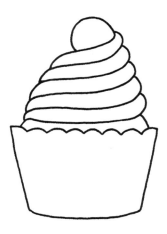

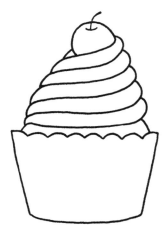

7. Put a cherry on top! Nestle a semicircle into the swoop of the top line.

8. Draw a smiley mouth in the cherry, then draw a cherry stem with a thicker end. Swoop the frosting around the cherry with a short line.

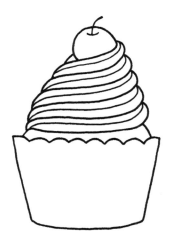

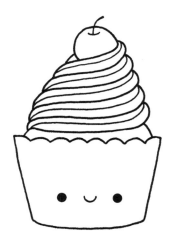

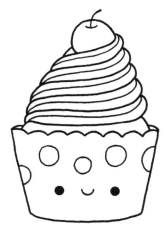

9. Draw five inner lines in the frosting using a fine point pen.

10. Draw a cute face, of course!

11. Decorate your cupcake liner with a favorite pattern using a fine point pen. Add sprinkles to the cupcake, if you like!

HOW TO DRAW Doodle Monsters

 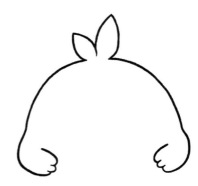

1. Draw two connecting leaf shapes.

2. Draw two curved lines off the leaves.

3. Draw the arms and hands, with fingers, curving the elbows out a bit.

 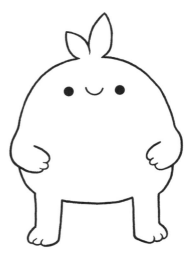

4. Draw two short, curved lines below the arms, a little way in from the elbows.

5. Draw the legs and feet, with toes, in proportion to your arms and hands. Connect the legs with a slightly curved line.

6. Draw a cute face, of course!

1. Draw an upside-down U shape with the ends curving to the left.

2. Draw a scalloped edge, making sure the scallops curve to the left to show movement.

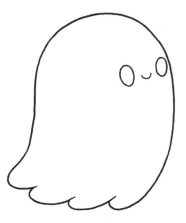

3. Draw a cute face, of course!

4. Draw some simple arms and hands.

HOW TO DRAW A Donut

1. Draw a semicircle, then draw a wavy line for the gooey glaze.

2. Draw in the bottom curve to complete the circle.

3. Draw a smiley mouth in the center of the donut.

4. Draw a small arc in the center of the smiley mouth for the donut's hole.

5. A little above the small arc, draw a wavy line for even more gooey glaze. Draw a cute face, of course!

6. Don't forget the sprinkles! Use a fine point pen to draw them.

HOW TO DRAW A **Clipboard**

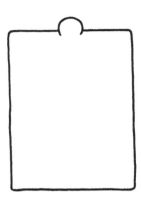

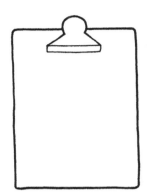

1. Draw a small semicircle.

2. Draw a rectangle with rounded corners from the sides of the semicircle.

3. Draw slanted lines off the ends of the semicircle and connect them with a narrow rectangle.

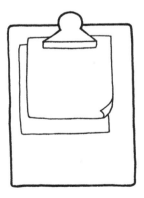

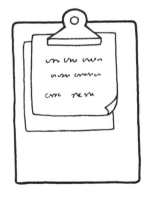

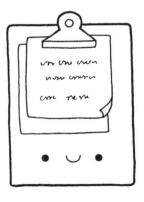

4. Add pages to the clipboard.

5. Add some details to your pages with a fine point pen.

6. Draw a cute face, of course!

HOW TO DRAW A Pencil

 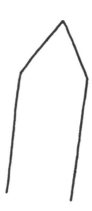 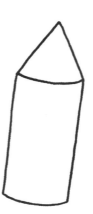 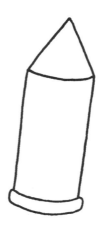 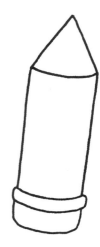

1. Draw an upside-down V shape.

2. Draw straight lines from the edges of the V shape.

3. Draw a slightly curved line to connect the sides.

4. Draw a curved line parallel to the one in step 3, then connect them.

5. Draw a three-sided rectangle with. rounded corners.

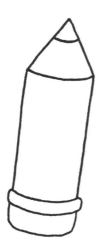 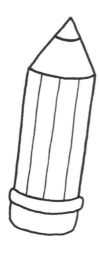 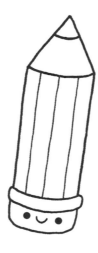 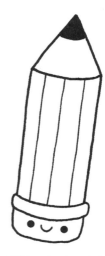

6. Draw a slightly curved line at the tip for the lead.

7. Decorate the body of your pencil using a fine point pen. I drew three vertical lines.

8. Draw a cute face, of course! You can place the face in the point, if you like.

9. Fill in the lead tip.

Kawaii Doodle World

HOW TO DRAW A Potted Plant

1. Draw an incomplete oval.

2. Draw slanted lines from the sides of the oval, then connect them, making rounded corners.

3. Draw an oval-shaped leaf.

4. Draw another leaf off the first one.

5. Draw an arc between the two leaves.

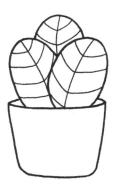

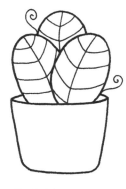

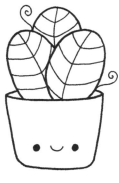

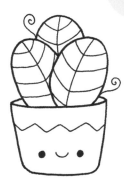

6. Using a fine point pen, draw the veins. Draw a line down the center of each leaf and then add large V shapes to each one. Try to space them evenly apart.

7. Add some decorative elements to your plant. I drew some tendrils.

8. Draw a cute face, of course!

9. Decorate your pot! I drew a zigzag line.

HOW TO DRAW A Planet

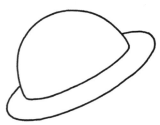

1. Draw a semicircle at an angle.

2. Close the semicircle, making rounded corners.

3. Draw an oval-shaped ring around the planet.

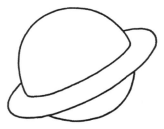

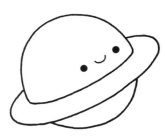

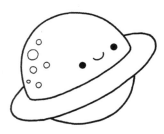

4. Draw an arc below the ring to complete the planet.

5. Draw a cute face, of course! Try drawing the face at different positions to see how the character looks.

6. Add some craters by drawing small circles with a fine point pen.

HOW TO DRAW A Star

1. Draw an upside-down V shape with a rounded point at an angle.

2. Add two "arms" to the star, making the V shapes a little fatter.

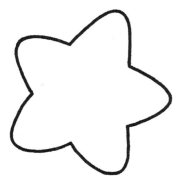

3. Add the "legs" to the star with even bigger V shapes.

4. Draw a cute face, of course! Try drawing the face at different positions to see how the character looks.

Fun Time!

The pages in this section are double the fun! They are Search-&-Find Puzzles that you can also use as coloring pages. Each of the following five puzzle scenes (two pages per puzzle) has a highlighted item that you need to search and find. The answers start on page 142.

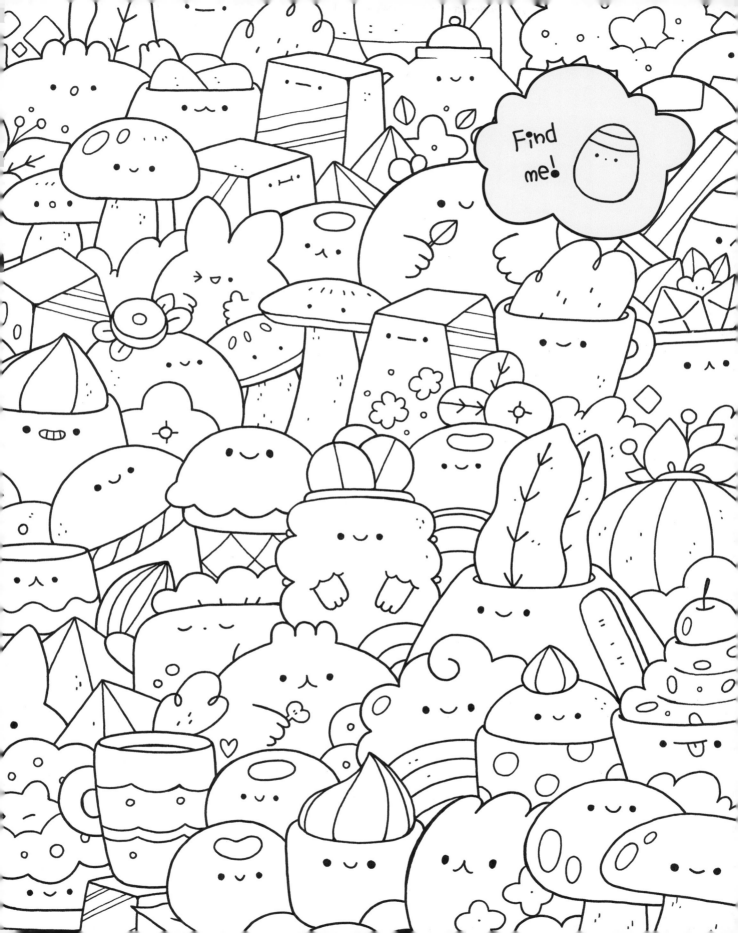

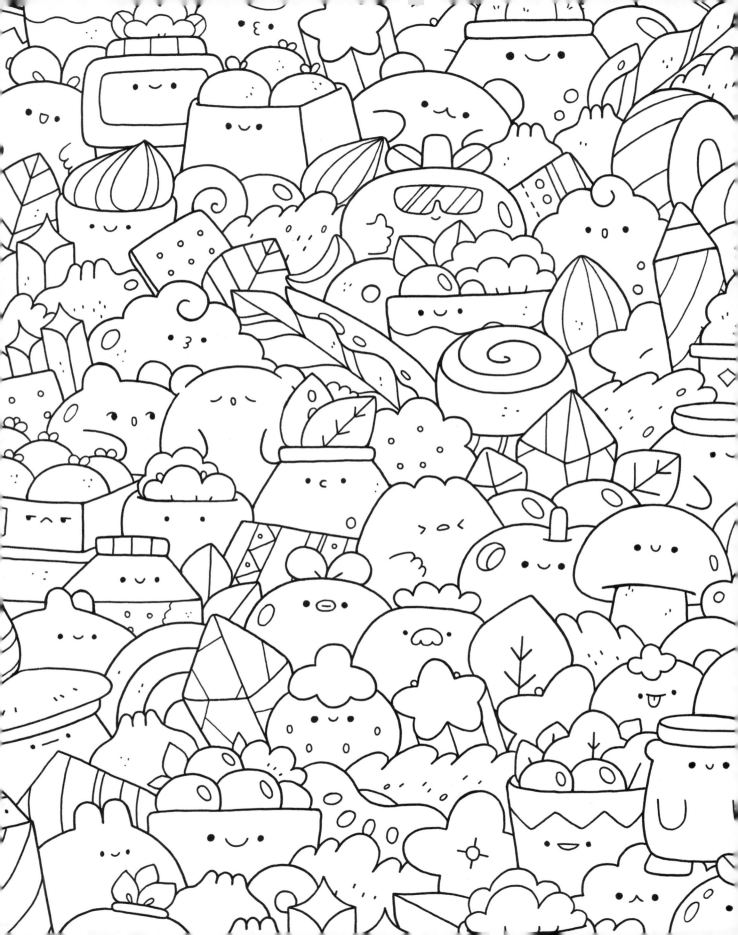

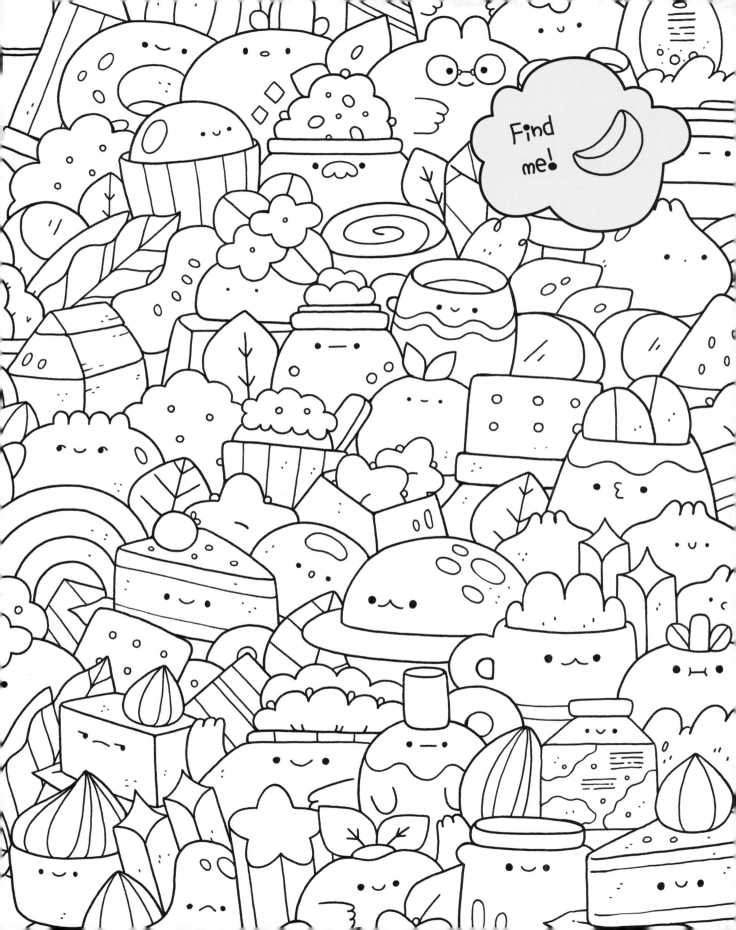

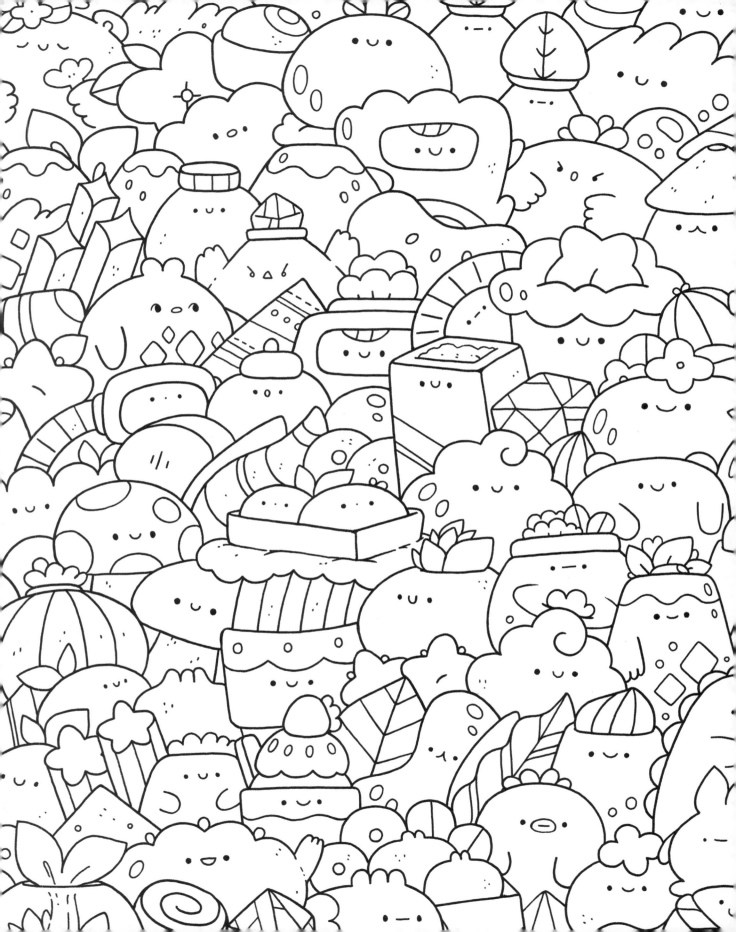

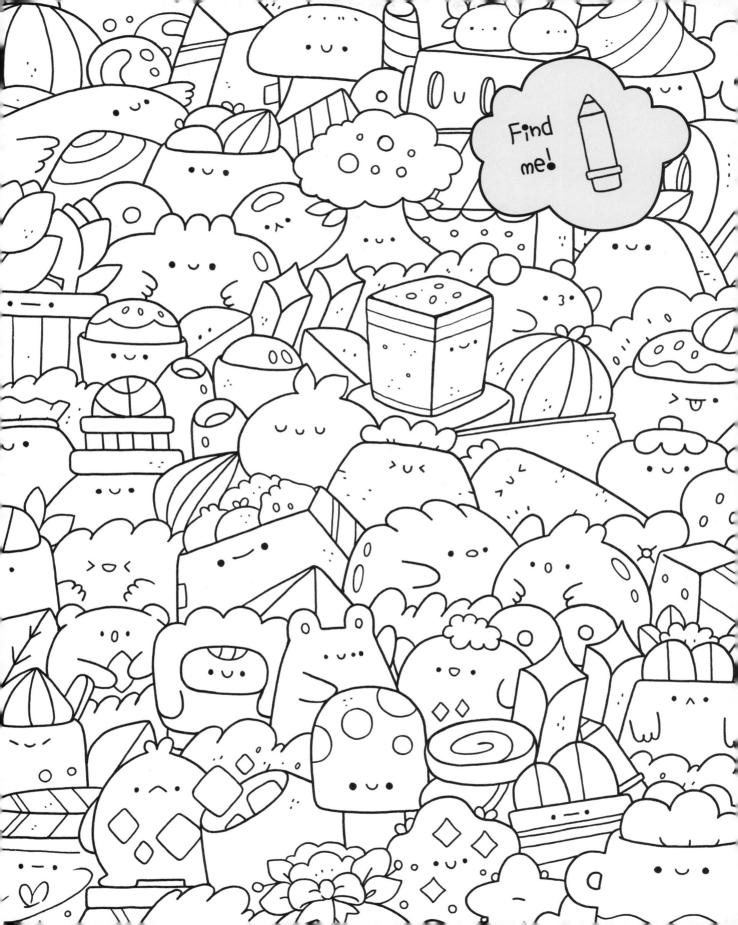

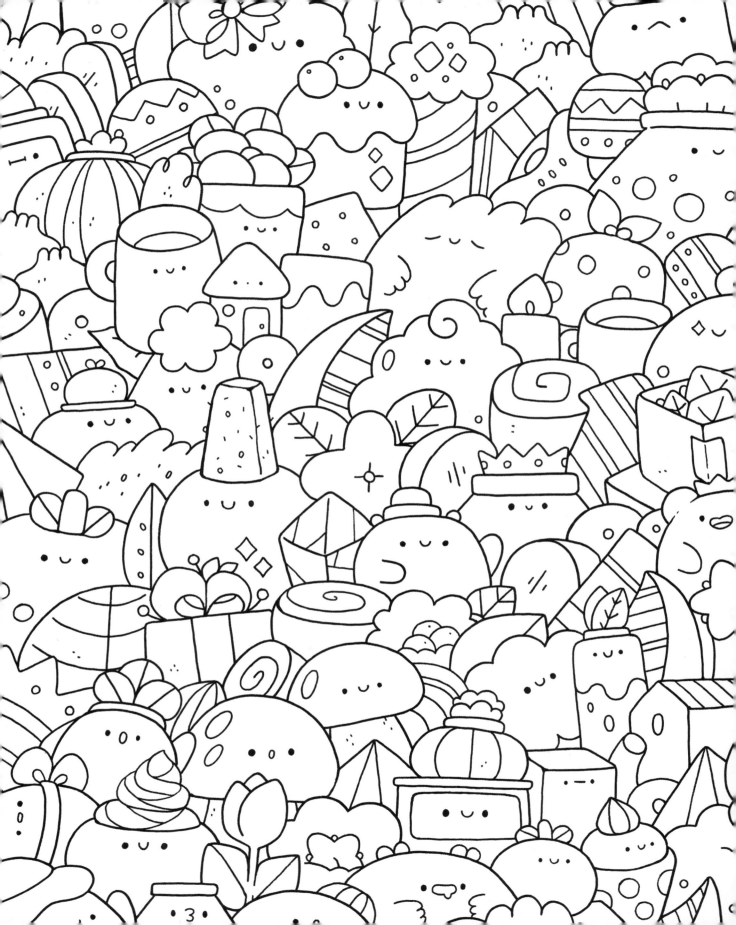

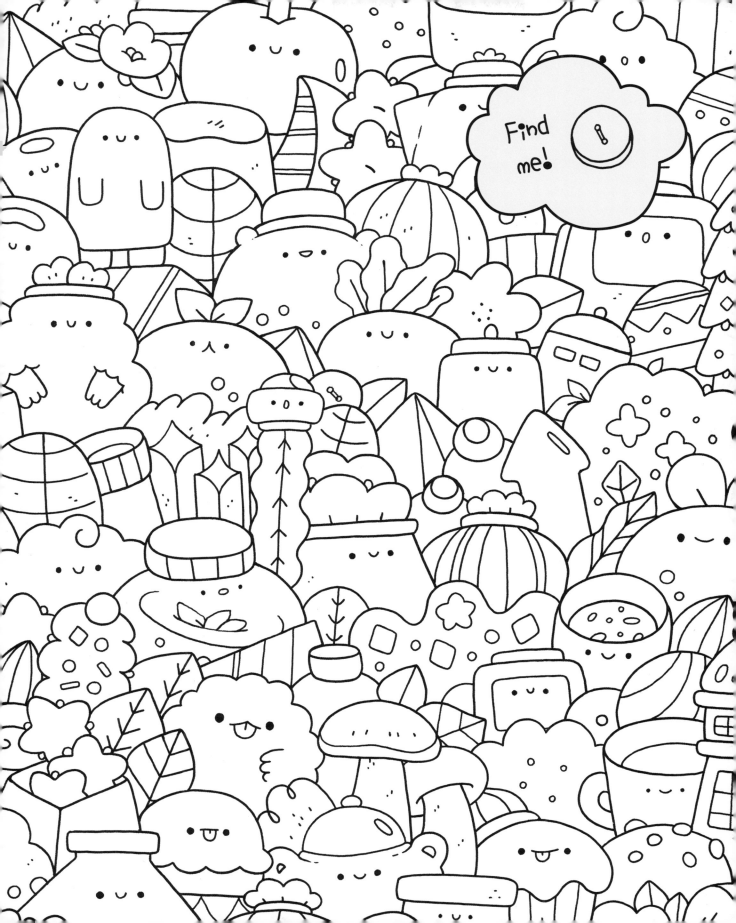

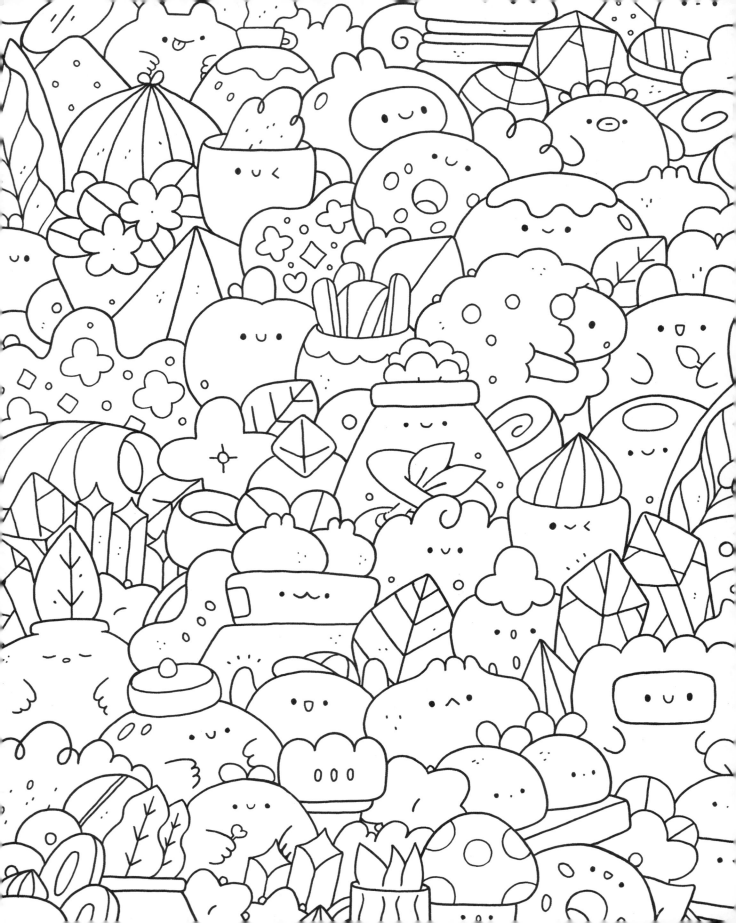

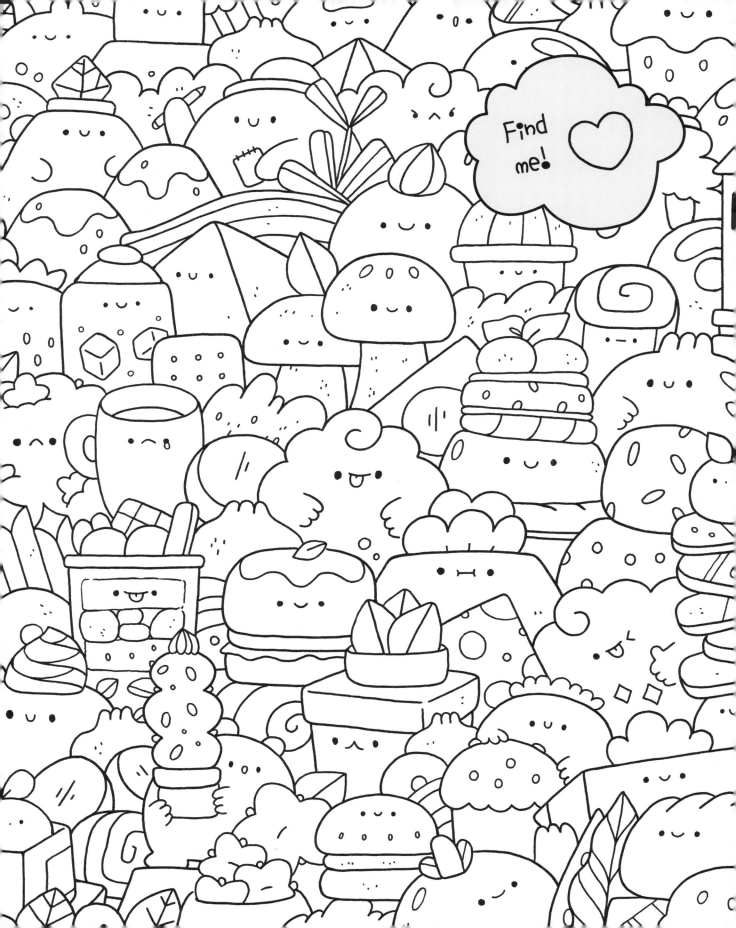

Search-&-Find Puzzle Answers!

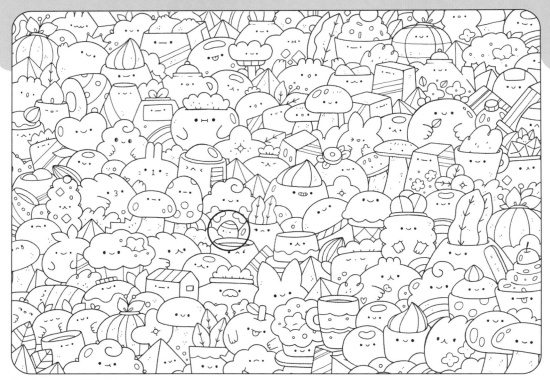

Key for pages 132–133

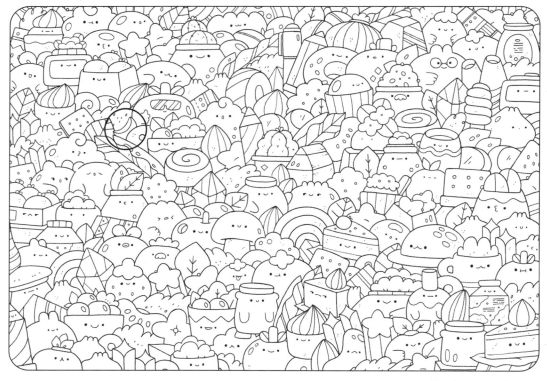

Key for pages 134–135

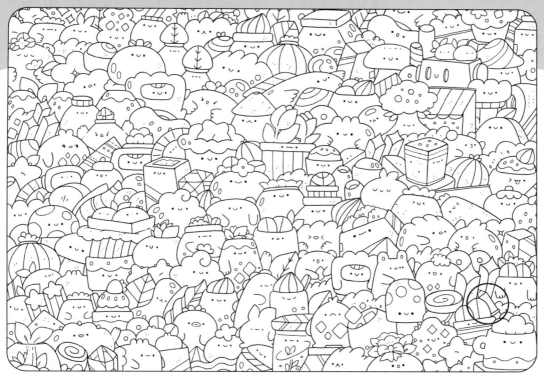

Key for pages 136–137

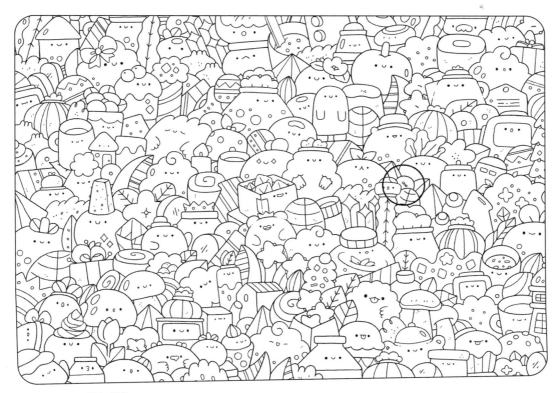

Key for pages 138–139

Fun Time! 143

Search-&-Find Puzzle Answers!

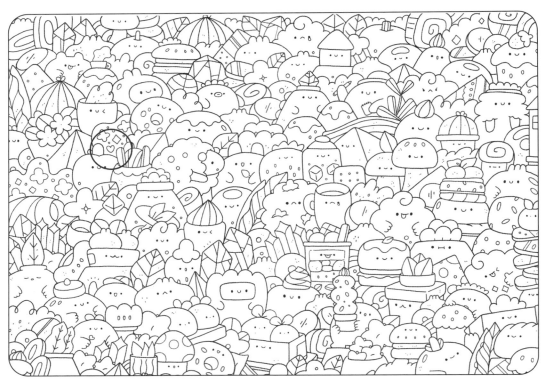

Key for pages 140–141

Pssst!
Check out these other super-fun books in the *Kawaii Doodle* series!

KAWAII DOODLE CLASS
Sketching Super-Cute Tacos, Sushi, Clouds, Flowers, Monsters, Cosmetics, and More
ISBN: 978-1-63106-375-6

KAWAII DOODLE CUTIES
Sketching Super-Cute Stuff from Around the World
ISBN: 978-1-63106-568-2